-0. APR. 1982

9026616 | RYAN, A | Still Life
Painting
Techniques.

J753.

451.45

78

Still Life Painting Techniques

Overleaf
Detail of *Still Life* 1613 by Floris Chaesz van Dijck
Franz Halsmuseum, The Hague
See also page 56

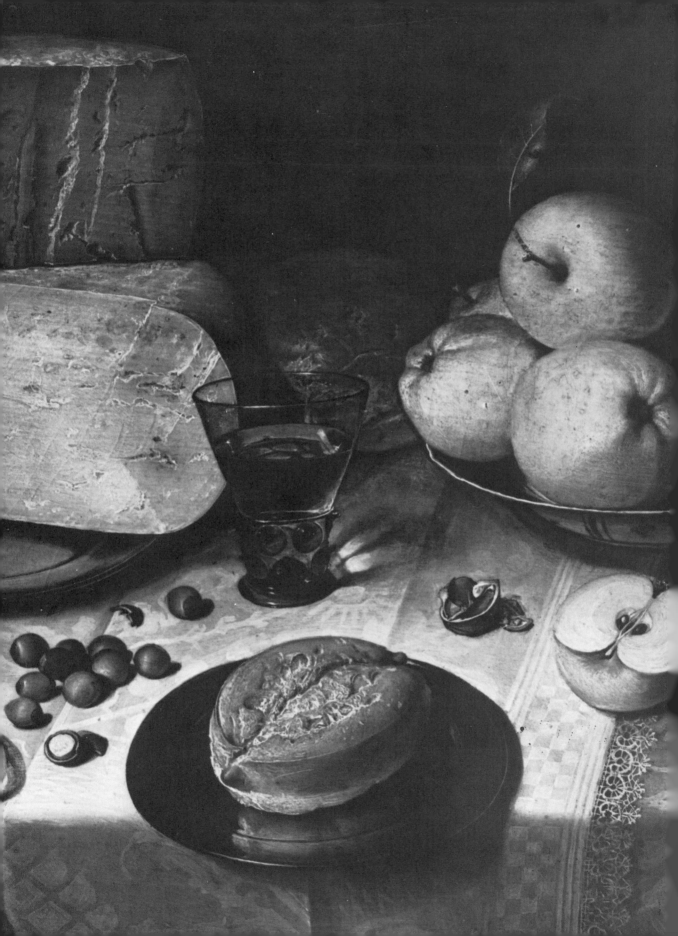

Still Life Painting Techniques

Adrian Ryan

B T Batsford Ltd London

To Haidee Giovanna
 Becker–Broessler

© Adrian Ryan 1978
First published 1978
ISBN 0 7134 0635 6

Filmset by Servis Filmsetting Ltd. Manchester
Printed in Great Britain by
The Anchor Press Ltd, Tiptree, Essex
for the publishers
B T Batsford Ltd
4 Fitzhardinge Street
London W1H 0AH

Contents

Acknowledgment

The author and publishers would like to thank
all the galleries and private collectors who have
given permission to reproduce the paintings in
their possession.

I would also like to thank those owners who
lent the paintings used in the practical section
and not formally acknowledged there, namely
Polly Walker and Cyril Cobbett.

My thanks too are due to Sue Curnow and
Peggy Ryan for much help and valuable
advice; and to Thelma M Nye, my editor, for
her guidance.

I am especially grateful to Bruce Pears who
took the photographs that illustrate the text,
and to Denise Bradley who typed the
manuscript.

Lower Holbrook 1978 *Adrian Ryan*

Preface

The aim of this book is to give both practical information and encouragement to those who wish to paint still life, and also to provide an outline of the history of the subject over the last four hundred years. The materials and pigments needed are listed, and the problems and difficulties of painting in oils discussed. I have tried not to overburden the beginner with too many technicalities, nor too detailed an historical background.

A bibliography is included for those who I am sure will wish to study certain aspects of both departments in greater depth.

The basic principles of still life painting apply equally to the practice of landscape, portrait and figure painting. It is hoped therefore that with the help of this book, the reader will feel able to venture further than the immediate subject of this study.

Still life remains the ideal first step for the beginner. Unlike landscape, it is painted indoors in the peace and quiet of one's own room or studio. Unlike portrait or figure painting it is not dependent on a model. Unless one is painting particularly perishable objects there is no need to hurry.

The paintings reproduced in this book show the remarkable range of subjects to paint and the many ways in which they can be interpreted.

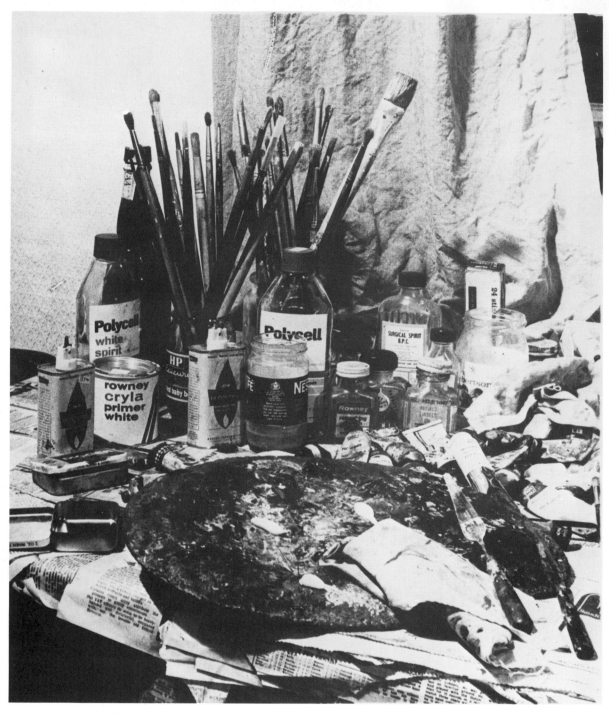

Typical disorder of an artist's painting table. I am here using a tobacco tin as a dipper, and lighter fuel as a vehicle. At least the brushes are clean!

Materials and equipment

About the philosophy of Aesthetics, to be sure we do not greatly concern ourselves, but we are considerably concerned about learning to paint.
Thomas Eakins (1844–1916)

Before making a first purchase of materials it is advisable to obtain a complete catalogue from an artist's colourman. These catalogues are informative and well worth the modest cost they sometimes incur.

Supports
This is the word given to the surface upon which the artist paints. It can be of canvas and canvas board, wood, hardboard, plywood, cardboard, and indeed paper. The surface however must be even and prepared for painting by the use of a primer, which is explained later.

Canvas
There are many different qualities of canvas ranging from very coarse grain to small grain with slight tooth, made of closely woven flax yarn. Cotton is not recommended as it is too thin and does not stretch well. Jute cloth is cheaper but has only a limited life.

Canvas Board
This is thin cotton mounted on thick board and is perfectly serviceable, though it lacks the 'give' of a stretched canvas. Canvas and canvas boards are sold ready primed. However one can buy unprimed yarn, and size and prime it oneself.

Wood
This support is seldom used nowadays and is not listed in most catalogues. An alternative is *hardboard,* a sheet of compressed and processed woodpulp, rough on one side and smooth on the other. It is on the latter that most painters work. It can be sandpapered to produce a less slippery surface. The rough side has a disagreeable machine-made patterning which a few people nevertheless prefer. This material has the advantage of being cheap, needing no stretchers, and being easy to cut to any size. It is also permanent. Plywood is an adequate alternative.

There are also on the market various painting and sketching pads prepared for oils which are equally suitable, though necessarily less permanent.

Cardboard and Paper
If sized, these can also be used, and have been, notably by Toulouse Lautrec, Bonnard and Vuillard.

Experience of every kind of support might be needed before one discovers the surface that best suits ones needs. The finer the surface the more detailed the work can be.

Stretchers
Canvas needs to be stretched to be painted on and for this stretchers are used. These are pieces of seasoned wood mitred and tongued to enable one to form a rectangular frame. They are made in a great variety of interchangeable pieces and are supplied with wedges, or keys, to tighten the canvas after stretching.

Canvases bought already stretched are of course more expensive than a separate purchase of stretchers and a roll of canvas.

9

Stretching the Canvas

1 Cut the canvas about 50 mm (2 in.) larger overall than the framework.

2 Make sure the bevelled edges of the stretchers are all facing the same way when assembled.

3 The rectangle should be absolutely right-angled (or it will never fit into a frame). To check this, measure across the diagonals with a piece of string. If the length of string needed is equal in both cases the rectangle is true. If not the stretchers will need adjusting by tapping the uprights in one direction or another.

4 Lay the canvas face down on a flat surface and place the framework, bevelled edges down, on top. (It is important to keep the smooth edges against the canvas or lines will appear later due to the pressure of the brush whilst painting.) Fold one side over, tacking it in the middle, either on the back or the edge of the stretcher. Using canvas pliers, stretch the canvas and tack in on the opposite side. Many artists these days stretch by hand and use a staple gun with wire staples. However, the old fashioned pliers and metal tacks give a more even and satisfying result.

5 Repeat the process with the other two sides.

6 Tap in nails about three inches apart on either side of the first nails and repeat on the opposite sides, making sure the canvas is stretched taut.

7 On reaching the corners, fold over as one would when making a bed and tack in to the back of the stretcher.

8 The wedges can now be tapped into place in the mitred tongue joints and the canvas further tightened if necessary.

If the canvas has not yet been primed, it is best to wait till that has been done before using the keys.

Priming

All the supports discussed above when unprimed should be given a coat of glue size dissolved in hot water and applied when warm to bind the primer to the canvas. When dry, the primer can be applied by brush. This is usually in the form of white lead, and several layers diluted with white spirit are advisable. One thick layer tends to crack and takes longer to dry. The object of this *ground* is threefold. To provide a good painting surface, to reduce the absorbency of the material, and to prevent the oil paint rotting the yarn. Both size and primer can be obtained from any artist's colourman. *Acrylic* based primers need no size and can be used on any support for oil painting.

Palette Knives

A stretched canvas has more give than wood or board; and is an easier surface from which to remove paint with a palette knife, when a mistake has been made or the paint seems too thick.

Here again there are different sizes and designs which become a matter of preference with experience. A straight blade with rounded tip is ideal for cleaning the palette and removing unwanted paint from the canvas. A knife with a cranked blade is also suitable Flexible steel knives, trowel shaped, are best for applying paint or for mixing the colours on the palette.

Brushes

Brushes are however the best possible tools for applying paint, and provide the artist with the means for personal expression as individual as handwriting. Once again the shapes and materials employed are many and various—and again practice will enable the artist to find the ideal design for the particular end. Sable is best for fine work; hog bristle for more vigorous brush strokes. The shape of the ferrule is important. Nickel-plated round seamless ferrules on long handles, give a freedom of movement on the canvas which the pinched ferruled brushes do not. In the case of the so called flat brushes, the very squareness of the tip dictates the kind of stroke which can be made. There are also brushes with pointed tips and pinched ferrules—the filbert shape—which are less restricting. A reasonable assortment of all three in various sizes should be kept. After use they must be thoroughly cleaned, first by rinsing in turps and then washing in soap and

Three canvases with their keys and a stretcher
25 cm × 20 cm (10 in. × 8 in.) which is the
smallest practical size for a little study. The
three most convenient sizes of tubes are
numbered 8 (the smallest here), 14 (studio tube)
and 20—which is an economic size for flake
white. The larger no 40 is rather unwieldy and
heavy. The straining pliers are the traditionally
shaped ones. I use a screwdriver for removing
the tacks when wishing to re-use the stretchers.
Interchangeable stretchers 44 mm ($1\frac{3}{4}$ in.) wide
are available by the centimetre (inch) from
12 cm to 91 cm (5 in. to 36 in.) from artists'
colourmen and should adequately cover any
but the largest and most ambitious still lifes.

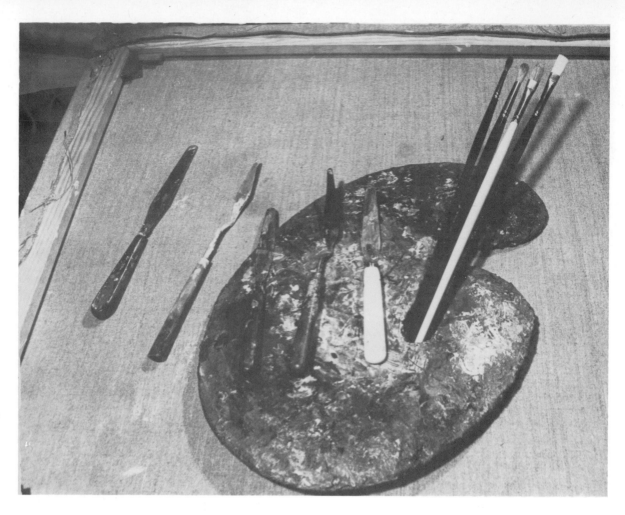

An oval palette, the five different palette
knives most commonly used and four kinds of
brushes; a sable and three hog bristles, one
with rounded ferrule, then the filbert type and
finally the flat ended, and least recommended.

cold water. The hairs should be smoothed to a point with the fingers and allowed to dry bristle uppermost. Detergents should not be used for fear of loosening the adhesive that fastens the bristles to the ferrules. Brushes that have been used with acrylic colours must be thoroughly washed straight away.

Palettes

Palettes are usually made of mahogany, and are oval, oblong or rectangular in shape, light enough to hold comfortably and large enough to allow room for supporting and mixing the colours. They need not necessarily be held, but can be rested on a table. Indeed a glass topped table or any smooth non absorbent surface can be used as a palette. Whatever the choice, it must be kept clean and after the removal of paint polished with a rag and some turpentine or linseed oil. Pads of disposable paper palettes are available and are useful when travelling as they are considerably lighter.

Dippers

Dippers are containers for oil or turpentine, or both, and can be clipped on to the palette or placed on a painting table. There are tin dippers with rims to prevent spilling but these are not so easily cleaned as a china cup or similar smooth non-plastic holder. They should be cleaned at frequent intervals. Dirty medium will ruin the colours. At least two dippers should be in use. One can be a jam jar with a large amount of turpentine or white spirit in which to rinse the brushes, and one much smaller with the particular medium being used for the actual painting, in which to dip the clean brush. It is this dipper that it is essential to clean and renew whenever it shows signs of discolouration. Painting rags are needed for wiping the brush after rinsing and before dipping. This should be done, but seldom is, after every brush stroke. Never throw away any old sheets, shirts or pillow cases. These make excellent rags, as do all cotton materials.

Mediums

Mediums or vehicles are the liquids used to make the paint pliable. In the case of oil painting this is usually turpentine which thins the paint, and linseed oil which retains the brilliance of the colours when they have dried out. Petroleum, pure gasoline or lighter fuel can also be used. The advantage here is that it dries much quicker allowing a second layer to be undertaken long before the slower drying oil or turpentine. Even slower drying is poppy oil with which the paint in the tube was first mixed. It would seem superflous to use more of it.

Easels

Easels should be firm and radial if possible, ie able to tilt forward or backward. Unless one has a large area in which to paint, a folding easel is recommended and is perfectly adequate. Sketching easels too can take most of the sizes of canvas that are needed for still life. It is quite possible to paint without an easel just by placing the canvas (provided it is small) on the seat of a chair and leaning it against the back. Many pictures have had such humble beginnings. Nevertheless an easel can be a lovely piece of furniture and like a bookcase or a writing table, accompany one through life.

The Artist needs but a roof, a crust of bread and his easel, and all the rest God gives him in abundance. Albert Pinkham Ryder (1847–1917)

Page 14
This painting of two trout was done on a canvas board 30 cm × 40 cm (12 in. × 16 in.). The detail shows the somewhat mechanical feel of the material and how the paint seems to be dragged across the rather coarse surface.

Page 15
In contrast to the trout this smoked haddock was painted on a fine canvas and the detail clearly shows how much more varied the brush strokes can become on a well primed ground. The sable brush and the palette knife (to remove excess paint from the canvas) can both be used more freely and a contrast between thick and thin paint is easier to achieve.

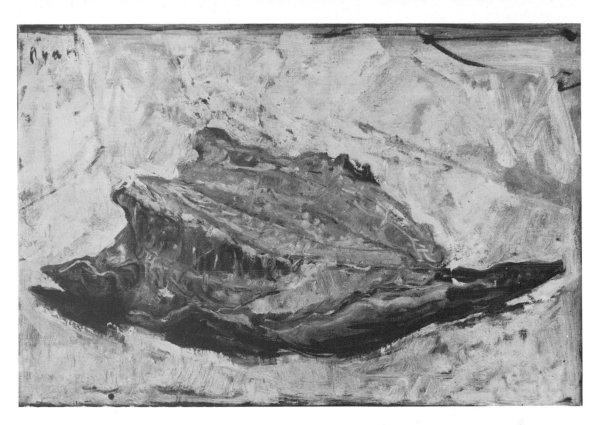

15

Pigments

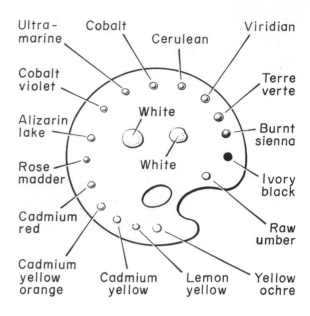

The earth colours on the layout of this palette have been placed either side of the black

Today most painters rely on artists' colourmen to supply oil paints, though it is still possible to grind our own if we have the time. This consists in mixing powdered colours into a fluid vehicle, namely poppy oil. The benefit is mainly that the consistency of the paint can be varied to the requirements of the user. Most tubes of paint these days are of uniform consistency and do not necessarily need an addition of oil. If the paint feels too oily it can be squeezed onto blotting paper before being transferred to the palette. There are over one hundred oil colours listed in the catalogues of the best known makers. It is wise therefore to start with a limited range and to add to it from time to time until a personal preference appears. The great masters are as easily recognized by the colours they use as by their manner and subject matter.

The colours listed below are all permanent and are all a beginner needs to start with:
Blues—ultramarine, cobalt, cerulean.
Yellows—lemon yellow, cadmium yellow.
Reds—cadmium red, alizarin lake, rose madder.
Orange—cadmium yellow orange.
Green—viridian.
Violet—cobalt violet.

These are the three primary and three secondary colours to which most painters add the following earth colours:
Yellow ochre, burnt sienna, raw umber, terre verte.

The following earth colours are somewhat stronger and need careful control: raw sienna, vandyke brown, light red, indian red, venetian red, and burnt umber.

Black and white complete the palette.
Ivory black is a richer deeper black than lamp.
Whites There are three generally used whites: flake, titanium, and zinc.

Artists are much divided on their virtues, and curious as it may seem there are differences in the qualities of these whites as well as in their 'feel'.
Zinc white (zinc oxide) is less opaque, slower drying and can form a skin, which can crack and fall off. It is on the cold side. It dates from the late eighteenth century.
Flake white is the earliest known white, a basic lead carbonate and is very opaque, quick drying and permanent—but also poisonous. It is not used in water colour form.
Titanium white (titanium dioxide on a base of barium) is fine but also dense and opaque and non poisonous. It was first made in this century. I use both flake and titanium.

Painting can be an expensive occupation, especially for someone starting from scratch. The following colours are the cheapest

available that still give a balanced and adequate palette. Ivory black and flake white; the earth colours—yellow ochre, raw and burnt sienna, raw and burnt umber, vandyke brown, terre verte, light red, indian red are all among the cheapest paints, though vandyke brown is only moderately durable. The others are extremely permanent.

Also cheap are permanent blue, prussian blue, chrome lemon, chrome yellow, chrome orange, chrome green and permanent mauve. These too are moderately durable. To this palette can be added at a slightly higher cost alizarin crimson and french ultramarine, the combination of which produces a rich dark shade.

Beautiful but expensive are the cobalts and cadmiums, viridian and vermillion. Nevertheless it is worth having in time a little store of each.

Paint is too expensive to waste. If there are colours left on the palette at the end of the day, they can be removed by the knife and put under water in a shallow tin, where they will retain their plasticity.

Acrylic colours are made with the same organic and natural pigments as oil colours but are bound with a water emulsion of acrylic polymer resin. They can be used on almost any non-oily surface. These paints can be used in all ways like oil colours but with water as a vehicle, working from a very thin wash to a thick impasto. They are particularly suitable for covering large areas of flat colour and are much used by artists of the so called Hard Edge School.

There are three potential drawbacks however to this medium. First, there are as yet less than half the number of colours available compared to oil paints. Secondly they are extremely quick dryers and when dry are hard and fast on the support. For some artists this is excellent but for the painter who likes to work his paint surface, altering from hour to hour and scraping off the paint from day to day, this becomes impossible. Thirdly, at the time of writing, many painters affirm that, in drying, the lighter colours tend to darken, and the darker appear

to lighten. This may prove to be a permanent characteristic of the acrylic medium or it may be that in time this will be corrected. It remains therefore a hazard for those who are trying to obtain an immediate matching of the colours they are looking at. Most users of acrylic paints soon adjust to this slight but noticeable happening. Their advantages are that water is an easier, cheaper, and on the whole, cleaner vehicle than oil; that when used out of doors their fast drying quality becomes as asset in Alla Prima work; and that their durability and permanence are likely to prove greater than those of oil paints. However they have only been in use since the nineteen sixties and this remains naturally a conjecture. Supports should be primed with ready to use acrylic primer obtainable from artists' colourmen. Two coats are necessary for an absorbent surface, the first diluted by 1 : 5 water; and the second undiluted. Cyrla primer gives a pure white matt surface which enhances the brilliance when glazing a colour. There are manufactured mediums that can be added to water to obtain a gloss effect, or a matt effect; and others to obtain more transparency. There is also an acrylic retarder which slows down the normal drying process. Acrylic medium is an adhesive as well as a diluent. Unused paint can be kept moist under a film of water. Acrylic paint can not be used over oil paint. Oil paint can however be used over a coat of acrylic. It is not advisable to mix different brands since the differing types of resin used may be incompatible. Nylon brushes, of the same designs and sizes as oil hoghair and sable can be used and are cheaper and harder wearing; the paints too are cheaper than oils.

There have been of course many still lifes painted in mediums other than oils, notably water colours. Although this book is not concerned with the technique of water-colour painting, many beginners may like to make a water-colour study of the still life they intend to paint in oils. A similar palette to that used in oil painting can be made up with the following water colours, bought either in pans (small cakes of solid medium) or in tubes: Yellow ochre, lemon yellow, cadmium yellow,

17

cerulean blue, cobalt blue, ultramarine, alizarin crimson, cadmium red, light red, viridian, terre verte, ivory, black.

All these colours are permanent, though paintings should not be exposed to strong light over a long period. Chinese white (a preparation of white oxide of zinc) is also permanent and many artists use it as a body colour. The addition of white to any water colour will immediately make the medium opaque. Thus, water colours can be used in the same way as oils, with washes, glazes, and with opaque half tones and highlights.

Traditionally this is not the way to use water colours; the purists leave the white paper as the highest light and apply transparent washes for the darks. For this a thick paper is used, which is expensive. But for a preliminary sketch any paper can be used from rough to smooth, that will take a wash.

Gouache is a very opaque water colour bound with glue and an admixture of white pigment. This lacks the transparency of true water colours but has greater covering power, and will obliterate a darker colour.

Egg tempera in tubes is now available and can be used like water colour or gouache. It is waterproof, however, so brushes used with this medium must be promptly washed. It should be used over a gesso ground, which nowadays means any white substance or powder (ie plaster of paris) that can be mixed with water.

Oil pastels are also employed by artists both for sketching and as an art medium in its own right. They are more resistant to rubbing than chalks and are less affected by fixatives, which tend to darken the brilliance of ordinary pastels. *Oil crayons* too are useful and do not smudge. Both these materials are free blending and can be manipulated in all manner of ways. Experimenting with one colour on top of another will give one an indication of what can be achieved by glazing and scumbling with oil paint.

Colour

My choice of colours does not rest on any scientific theory. It is based on observation, on feeling, on the very nature of each experience.
Henri Matisse (1869–1954)

There are seven colours in the spectrum though the average man or woman sees only six—red, orange, yellow, green, blue and violet—the seventh being indigo.

Red, yellow and blue are known as the primaries. Violet, orange and green are called secondaries, being the colours made by mixing two primaries.

Red + blue = violet
Red + yellow = orange
Yellow + blue = green

Every colour has five qualities and it is important to understand the definition of the words used to describe them.

1 *Hue* the colour itself, ie red, green, yellow, etc. (Tint is used to describe a hue weakened by adding white or another lighter colour. When a hue is darkened by adding black or a darker colour it is known as a shade.)

2 *Value* the relative lightness or darkness of a colour.

3 *Chroma* the relative brilliance of a colour.

4 *Transparency* some colours are more opaque than others giving a thicker feeling to the surface. Transparent colours are best used in shadows and for glazing. To discover which colours are more or less transparent lay a wash on a thin piece of paper and hold it up to the light. Most colour merchants mark their lists with a T against their transparent colours, but it is best to find out for yourself as there are degrees of transparency in every colour.

5 *Temperature* or what is called hot or cold colour. Basically red and yellow are warm, blue and green are cool. Red becomes cooler with the addition of blue = violet. Yellow becomes warmer with the addition of red = orange. These terms do not have a scientific validity—they are based entirely on association. Goethe claimed in 1810 that human beings responded biologically to colours (as does the animal world) finding red, orange and yellow exciting, and blue and purple anxious, tender and yearning. The paintings by Picasso done in the years 1901–4 and known as his Blue Period are a good example of this quality of colour. In the many paintings of the mourning Virgin Mary her clothes are nearly always painted purple. It can be seen therefore that the study of colour is not only physical but also psychological and physiological.

There have been many books written on the theory of colours since Michel-Eugene Chevreul produced his work on colour harmonies in 1839, first published in English in 1872 under the title *The principles of harmony and contrasts of colours*.

In spite of all these theories and scientific studies, whether based on mathematics or laws of aesthetics, no method of measuring colour harmonies has been discovered. They remain still the magic and the poetry that the artist creates. However, many painters of the last two centuries have studied the theories of Goethe and Chevreul and the American artist Ogden N. Rood (*Modern Chromatics* 1879), among them Turner, Delacroix, and Seurat. There are basically two kinds of harmony; harmonies of analogous colours, and harmonies of contrasts.

These can be demonstrated clearly with the simplest of charts (right). Having made a colour circle using the primaries and secondaries similar circles can be made by reducing the colours with white or shading the colours with black. A completed colour chart—in which the colours have been mixed in regularly diminishing or increasing proportions, will give one both analogous harmonies, ie, two or three hues that occur on the wheel side by side, and contrast harmonies being the colour directly opposite on the chart, (the complementary colour). Thus the complementary colour of red is seen to be green, of yellow, violet, and of blue, orange, and so on round the wheel.

All colours are relative and affected by adjacent colours. Just as a grey bordered by black, and the same grey bordered by white appears to be different in intensity so any colour bordered by another is similarly affected. Much time can be spent in compiling colour charts and value scales but perhaps for the beginner the time could be better spent painting from nature, and discovering by experiencing.

What exactly these stimulus situations of colour mean to the artist has been best and most romantically described by Sir Charles Eastlake (1793–1865) one time President of the Royal Academy:

If flesh, for instance, is never more glowing than when opposed to blue, never more pearly than when compared with red, never ruddier than in the neighbourhood of green, never fairer than when contrasted with black, nor richer or deeper than when opposed to white; these are obviously the contrasts such exaggerations respectively require, because they are the truest mode of accounting for them.

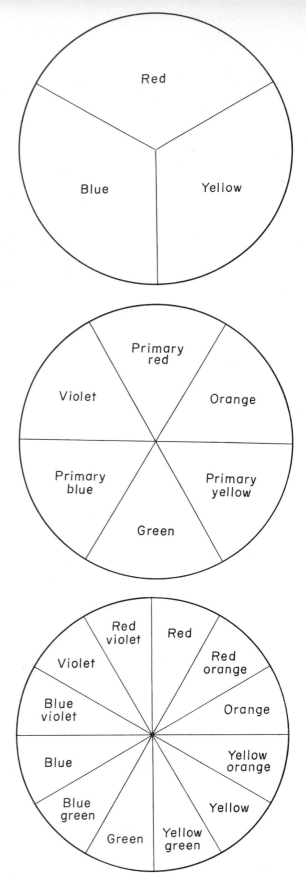

Choosing a subject

I try not to have things look as if chance had brought them together but as if they had a necessary bond between them. Jean Francois Millet (1814–75)

As one can see from the reproductions in this book the painter of still life has an almost limitless choice of subject matter. It is curious that the kitchen and the breakfast table still provide us after four centuries of still life painting with the most pleasurable objects. Perhaps these humble domestic utensils and table wares give us and the spectators a feeling of home and comfort. Certainly the choice we make of what we paint cannot be without some conscious or subconscious association. We paint best what we love most.

It is sensible to start with familiar and permanent objects, forms that one knows which do not change colour. Under this category come jugs, cups, bottles, glasses, cutlery, books and everyday articles, all of which can be happily arranged together. Most loaves of bread have interesting shapes and along with certain cheeses and cooking apples can be painted for a longer period than most perishable foods. Nearly everything we eat can and has been painted, from vegetables and fruits, to game and fish. Almost more fragile and passing are the flowers we pick. The artist must learn to overcome the problems such impermanence brings. Nearly all the above can be substituted from day to day without a great divergence of form or colour.

Where this is not possible a drawing with colour notes should be made, from which one can hopefully continue to work the next time.

With the ever changing designs on domestic wrappings such as cigarette packets, tins of tobacco, and breakfast cereals, and the differing shapes of coffee pots and cups, still life painting becomes a commentary on our way of life, a social history in miniature.

Henri Fautin-Latour (1836–1904)
Cup and Saucer
A little exercise in painting that is always worth attempting, the study of a single simple white object with its close gradations of grey. Here the artist has reversed the traditional manner and left the bare canvas as the lightest white and used progressively thicker paint in moving through the half shades to the darker shadows.
Fitzwilliam Museum, Cambridge

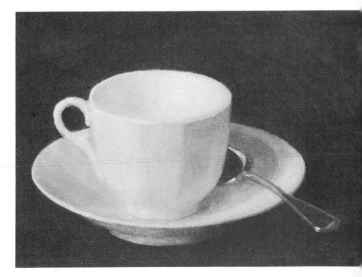

Components

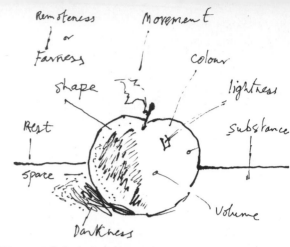

Painting is concerned with all ten attributes of sight, namely: Darkness and brightness Substance and colour Form and place Remoteness and nearness Movement and rest.
Leonardo Da Vinci (1452–1519)

This simple diagram explains how these attributes of sight can be expressed in a two dimensional manner. It will be seen that movement and rest is achieved by contrasting rhythms, vertical and horizontal lines conveying rest, and contours and broken surfaces, movement. The other eight attributes are demonstrated by the skill of the painter's brush. Darkness and brightness (lightness) by the use of chiaroscuro, substance (the surface texture of objects) and colour by the application of the paint itself, as in Vermeer's handling of the bread and basket (opposite); form and place, by shading to describe volume, and by the use of tone to define space; remoteness and nearness by the use of both lineal and colour perspective.

The use of the word tone in this book to describe space must be defined at once. So many different versions have been given to the meaning of the word that there has always been confusion. Indeed some people maintain that there is no such word when applied to painting —and that it should refer only to the monochromatic photograph. Tone is used here as indicating the strength of colour, light or dark, tint or shade, that is placed beside or on an object to convey the form of the object which is hidden from us (24). If these tones are wrong, either too strong or too weak, the object will appear to have had its back cut off— and to be no thicker than a sheet of paper. If the tone of one object against another is wrong, the hidden space between them will be inaccurate. Therefore I use the word shade

It is not possible here to show the colour of the apple; nor have I attempted to show the substance of the wooden shelf, nor the remoteness of the background. Apart from colour all these attributes can be expressed by line, as the great etchers and engravers have proved.

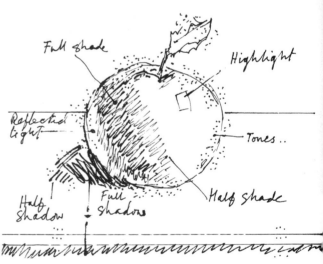

I have used dots on this drawing to help explain where the accurate use of tones is most important. In many paintings backgrounds and foregrounds are no more than a wash. There is no need to overpaint the whole canvas, but the areas surrounding objects must receive close attention, and constant reappraisal.

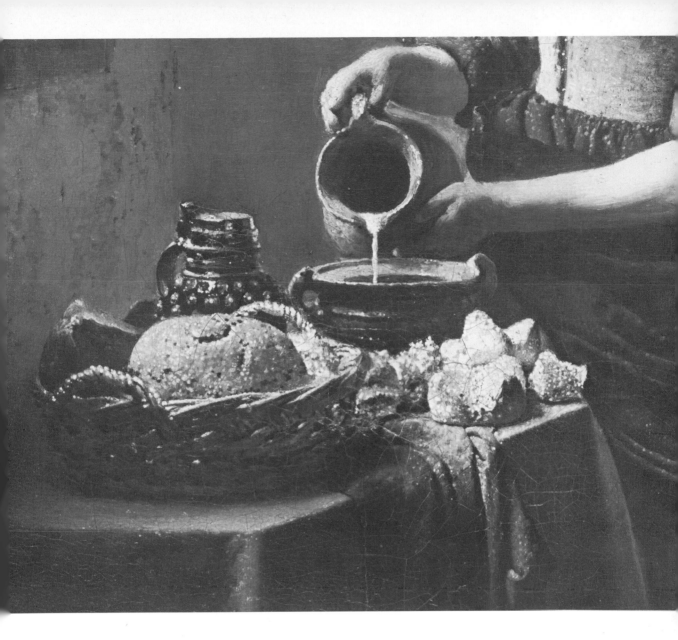

A detail of the bread, jug and basket from
Vermeer's 'The Cook' showing the use of paint
physically to depict the various textures
(substances) met with in still life painting.
See also page 64.

to describe modelling, the word shadow to describe the absence of light, and the word tone for all the modulations of colours that surround the object, and allow it to occupy its true volume in space. Tones are not of course confined to the surroundings alone but occur too on the objects themselves, so that adjustments in strength of colour on both surfaces are constantly being made to achieve one's aim. All these ten attributes are physical. But, as in the case of colour, the subject matter also contains aspects both psychological and physiological. This applies to all the different branches of painting, the historical paintings, the portraits, the landscapes, and paintings of the world of fantasy, as well as to our own still life. Figurative painting can not fail to be emotive and evocative.

The artist is born to pick, choose and group, with science, the elements in colour and form that the result may be beautiful.
James Abbott McNeill Whistler (1834–1903)

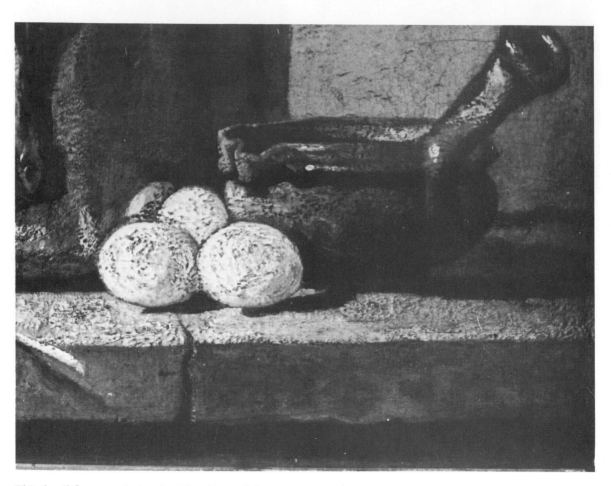

This detail from a painting by Chardin explains what is meant here by both form and place (or the volume of the objects and the space between them), being expressed in terms of light and dark.

Composing

For me all is in the conception. I must have a clear vision of the whole composition from the very beginning. Henri Matisse (1869–1954)

Having made a choice of subject matter for one's painting the next move is to arrange the objects in a situation that appeals to one, either on a table or a chair or even on the floor; in fact anywhere that seems appropriate. A single source of light, preferably coming from either the left or the right to give definite lights and darks should be chosen. It is important at this stage to decide on the shape and size of the canvas to be used. Many artists have used a viewfinder as a help in this initial phase. This is a rectangular hole cut in a piece of paper or cardboard through which one can look at the arrangement, moving the paper from side to side, or up and down, to give one an idea of the probable edges of the picture and the amount of background or foreground that might be best. It also helps to move round the subject oneself, finding a view point that is less formal and likely to give more excitement. The size of the canvas should be on the small rather than the large size, and should comfortably contain the group. Too large a canvas leaves a lot of unnecessary space to fill in, and lessens the tension between the objects.

The canvas should be placed on the easel at the same time as the still life is being arranged, so that one can look from one to the other and plan the design in one's mind.

There is little actual perspective in still life painting either in the sense of size diminution, as in landscape painting, or in the sense of receding parallels as in a street scene. However, much can depend on the eye level chosen and then the perspective will be concerned more with foreshortening (page 75) and ellipses (page 56) than with vanishing points (page 69). There are of course many eye levels one can use but they fall into variations of three positions, namely:

1 the eye level with the object
2 the eye above the object
3 the eye below the object.

Where the eye is level with the object there is virtually no perspective at all (page 88 right).

When the eye is high above the level of the objects the roundness of the objects is most marked, as in the painting by Matthew Smith (page 106). When the eye level lowers the ellipses are less marked (page 68), until finally there is no ellipse at all (page 65).

Still life paintings where the eye is below the level of the objects are much rarer, and used mainly by painters of the Trompe l'oeil school, usually on high walls and ceilings, to create an illusion of recess.

First impressions are not necessarily the best and an open mind throughout the process of making preliminary drawings will enable one to alter the composition on the canvas or to change the position of the still life on the table. What one is looking for at this stage is harmony of shapes, contrasts of texture and of light and dark, balance of colours, spaces and rhythms; in fact the ten physical attributes of sight and one's response to them. One of the most important points in the arranging of the objects is to ensure a sense of harmonious proportion between each and to avoid the incongruous placing of too large an object beside too small

25

a one. It is also best to avoid painting anything over life size, unless for a mural which is to be seen at a distance. Any natural form, such as an apple or a tomato, painted larger than we know it could possibly be, is known as an imbalance and can be visibly disturbing, especially when placed beside an object painted its true size. Many surrealist painters use such disquieting juxtapositions (page 105).

Artists have always, either instinctively or by design based their compositions upon geometrical divisions of their canvases or upon geometrical designs within these divisions. These divisions, or grids, are used to break the surface of the canvas into smaller areas.

The simplest of these is the division of each side into three equal parts, giving nine equal squares or rectangles and four intersections at places on the canvas most compelling to the eye (e). A second, often used division, is made by marking the length of the shorter side on the longer side of the rectangle, and, by repeating this process on the other side, achieving two overlapping squares. Drawing the diagonals of these squares, along with the diagonals of the rectangles gives one a pattern of oblique lines, or a network upon which to base one's design. This is known as the rabatment of a rectangle (a) and unless working on a very large scale should not concern us. The third most commonly used division is based on the golden section. The Golden Section or Mean is the name given in the ninettenth century to a proportion known in Euclid's day, namely a

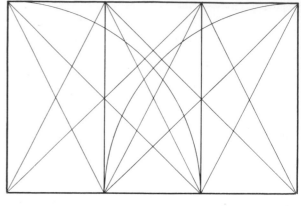

(a)

line divided in such a way that the smaller is to the larger as the larger is to the whole. In simpler terms, the proportion that arises is very nearly 5 to 8, so that if the canvas is 508 mm × 610 mm (20 in. × 24 in.) one could draw a line 380 mm (15 in.) along the longer side, and 318 mm (12½ in.) along the shorter side, to give one an approximate golden mean at their meeting point (g).

These devices can be used as a help towards composing the canvas but not as a strict rule to be followed at all costs. Instinct is still the best master. Within these grids the artist has frequently based his design upon the triangle (page 74), the diamond (page 90), the pyramid (page 97), and the diagonals (page 109); any pattern that is, that holds the eye to the canvas, but at the same time leads it round and back to a focus again.

(b)

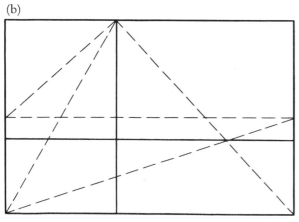

(c)

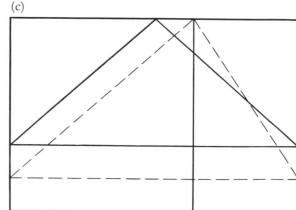

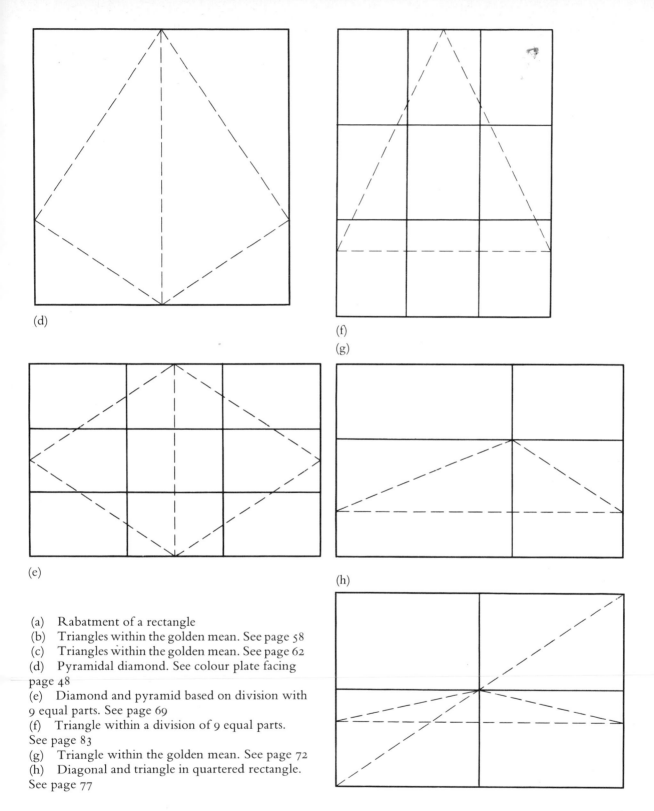

(d)

(f)

(g)

(e)

(h)

(a) Rabatment of a rectangle
(b) Triangles within the golden mean. See page 58
(c) Triangles within the golden mean. See page 62
(d) Pyramidal diamond. See colour plate facing
page 48
(e) Diamond and pyramid based on division with
9 equal parts. See page 69
(f) Triangle within a division of 9 equal parts.
See page 83
(g) Triangle within the golden mean. See page 72
(h) Diagonal and triangle in quartered rectangle.
See page 77

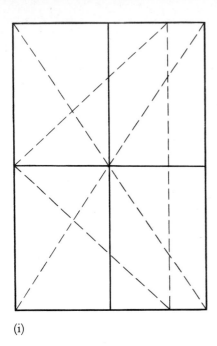

(i)

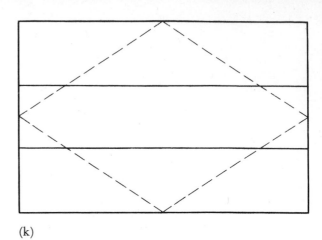

(k)

(i) Diagonals and triangles in a quartered rectangle. See page 70
(j) Polygonal pyramid. See page 97
(k) Diamond. See page 90
(l) Diagonals. See page 109

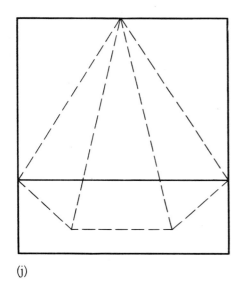

(j)

(l)

Golden Mean

On a canvas ABCD, DC is cut at X to equal

XC:DX = DX:DC

and BC is cut at Y to equal

YB:CY = CY:CB

A line drawn perpendicular from X to Z, and a line drawn horizontally from Y to W will give a harmonious division of the canvas, and provide at V an ideal point of focus.

To find point X bisect DC at E.

With C as centre and radius CE draw an arc to cut CB at F.

With F as centre and radius FC cut arc EF at G.

With D as centre and radius DG find the Golden Section at X.

To find point Y bisect CB, etc.

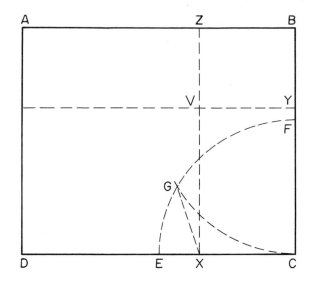

Finding the golden section

Finding a canvas constructed to the golden section

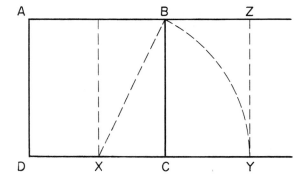

To find a canvas which is constructed to the Golden Section draw a square, divide it vertically into two equal parts, draw the diagonal of one of these, XB and with centre at X and radius XB cut the extended base DC at Y.

Draw a perpendicular line from Y to cut extended line AB at Z.

29

Squaring up

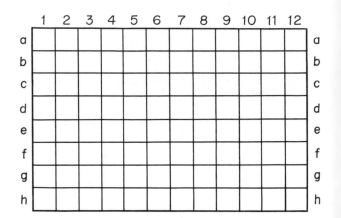

Some artists prefer to do a careful drawing of their intended painting on paper first and then to transfer the design to the canvas by the process known as squaring up. This can be done in two ways. First, divide each side of the paper into as many equal parts as the composition warrants—probably between ten and twenty. Draw the horizontals and verticals and number numerically along the top and bottom and alphabetically down the sides. Taking a canvas of the same proportions (but not necessarily the same size of course) repeat the process on the canvas. The design and detail of each separate square can then be accurately drawn in.

A second way is to draw diagonals across the drawing and then the vertical and horizontal lines through the centre of their meeting point. Continue to draw more diagonals, verticals and horizontals until you feel the drawing has been adequately subdivided for your needs.

Place the drawing in the bottom right hand corner of the canvas and draw the continuation of the diagonal; then, repeating the process from the bottom left hand corner, draw the verticals and horizontals through their meeting points and the canvas will be divided into the right proportions ready for you to transfer your drawing.

Pencil or charcoal can be used for this squaring up but I prefer to work directly with a diluted cerulean blue and a fine brush. By using oil paint from the beginning one avoids the danger of the picture becoming just a filled in drawing.

Starting the painting

The first two things to study are forms and values.
It is very important to begin by an indication of the
darkest values and to continue to the lightest.
Jean-Baptiste Camille Corot (1796–1875)

Every painter discovers his own method of approach with experience. It is therefore impossible to lay down the right or indeed the wrong way to begin. However, the blank canvas has to be marked, even if that mark disappears in the course of the process of painting. The first move therefore must be to draw in the design either in charcoal (which, unless fixed, dirties the paint that eventually covers it), or preferably with a thin wash of a sympathetic colour. Sympathetic that is to the subject! A group of green apples suggests the use of terre verte, bananas—yellow ochre; viridian or indian yellow would be too strong for this initial stage. Cerulean blue, being similarly pale, especially when thinned, is an excellent colour for the first drawing since the blue is soft and will melt with any later additions of paint. The original lines may have to be rubbed off with a rag dipped in turpentine. The slight residual wash of pale green or yellow or blue will not be a disadvantage as long as it remains transparent. The resulting drawing, which is what it still is, will not necessarily be the finished design. First impressions are not always the best and an open mind throughout the preliminaries will enable one to alter the composition on the canvas or change the arrangement of the still life on the table. The addition of darks may drastically alter the balance when they are washed in at the next step. It would therefore be best to use the preliminary strokes as a wash drawing, using a sable brush and building up from the shadows so that the design starts as a three dimensional

concept almost from the beginning. This method, with each artist having his own preference for the first colour used was most general until the start of the nineteenth century. (Frequently the canvas would have received a ground of a cool grey or a warm pale red, many artists preferring not to work directly upon a white surface.)

When Turner and Constable in England and subsequently Delacroix and the Impressionists in Europe moved into more immediate brushstrokes, covering the canvas at irregular intervals, many of these principles were still followed or adapted. (Nevertheless Jean Renoir has written that as a child he never knew what his father was painting until the picture was finished!)

The next stage when adopting the traditional approach is to wash in the local colours, still keeping the paint thin and transparent. Local colour is the general hue of the object; so that if one is painting a blue jug one would wash in the nearest equivalent colour on ones palette, probably cobalt or ultramarine. Being a wash only it would not of course at this stage be the true colour. It would be only an indication of the range of colours that one intended to use in the painting. This is then followed by the washing in of the shadows which will become an integral part of the design. It is therefore important to have established a single source of light so that the cast shadows are clear and help in defining the volume of the objects that are throwing them. The shadows where darkest should if possible remain transparent, even in

31

the finished painting. This is because once they become thick they tend to jump and come forward, whereas they are usually receding from or underneath the objects that are casting them.

The most difficult question at this point is what are the colours of the shadows, and are they warm or cool. For instance if the shadow is falling on a red surface such as a table cloth of that colour, the shadow will appear cooler than the surrounding red that is in the light. So that in such a case one would wash on a blue red from one's palette—most likely alizarin crimson. Similarly if the table cloth was blue, the shadow might well appear slightly warmer than its surround and a wash of cobalt violet could be used. These colours are still of course just the apparent colours and would need adjusting as the picture progressed. In order to keep the shadows transparent, the adjustments should be made if possible by glazing, that is by washing a darker colour over the first application. It is always better to have ones shadows too dark at the beginning than too light. Shadows are the drawing of the picture, they indicate where the weight of the objects fall and therefore describe their position in space. If they are allowed to weaken, the whole design dissolves, the drama disappears, and the objects appear to float and lose the tension between each other. Until now there has been no opaque mixing of two or more colours, nor any use yet of white. The general design and tonal range, apart from the highlights, have been established. It is at this stage that the painting looks its most promising, with its clean washes of pure, though diluted colour, and with its rich dark shadows. It is tempting sometimes to leave it as it is, seductive but alas still shallow.

Many artists in this century have at times stopped short of expressing volume by shading and shadows, or substances by texture and brush strokes, most notably the Fauves; but their intentions have been thus from the start of the picture. They have decided on a definite approach at the very beginning, using very strong colours and positive drawing for emotional effect, often of a decorative character.

This is not so with the manner that I am describing, which is a slow and contemplative building up of the paint.

I might be satisfied momentarily with a work finished at one sitting but I would soon get bored looking at it—therefore I prefer to continue working on it so that later I may recognize it as a work of my mind.
Henri Matisse (1869–1954)

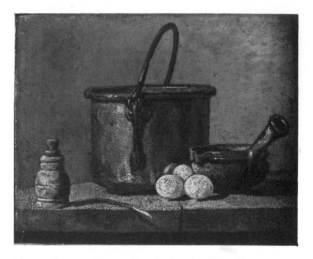

I have chosen this small painting by Chardin to demonstrate how one can build up a painting and what one should aim for from start to finish. By using a picture by a great master I have avoided the natural hazard of such demonstrations, namely that of ending up with a less than remarkable result! The following stages are by no means a faithful record of how Chardin himself constructed his work—that would be impossible. But I hope it shows how we can approach the same problems that he faced and the ends we pursue when we paint a still life.

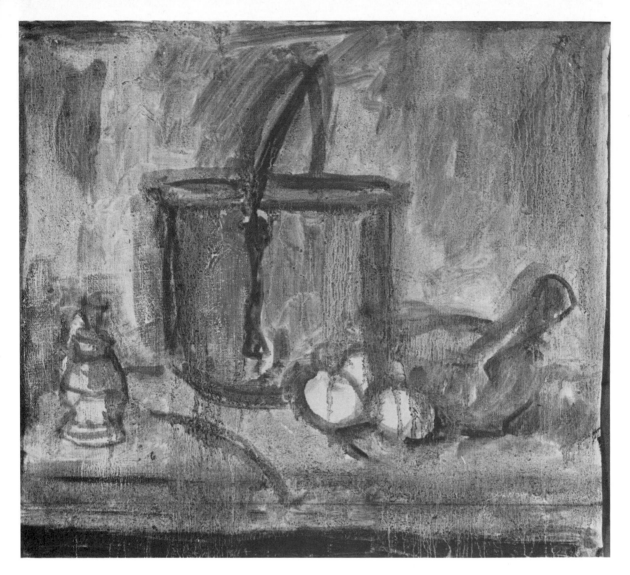

The first stage. The placing of the objects has
been attempted, with a faint wash of yellow
ochre to begin with, and further readjustments
made with the stronger burnt sienna. The
background has had a wash of terre verte to
cover the canvas and to provide a cool
background against the warmer coloured
cooking utensils.

Building up and finishing the painting

It's looking at things for a long time that ripens you and gives you deeper understanding.
Vincent Van Gogh (1853–90), letter to Theo,
September 1888

The full choice of colours to be used must now be added to the palette. White makes its appearance for the first time; Black too, though many painters prefer to use a combination of other darks, such as umber and prussian blue. It is also the first time that the colours have been mixed together other than by washes and glazes. Paint immediately becomes opaque when two or three are mixed or when white or black is added. These mixtures can however still be diluted and applied thinly, provided the under paint is thoroughly dry.

The addition of white to a colour both cools and reduces the brilliance. To maintain a colour's brilliance and yet lighten it a much larger proportion of the colour to the white should be used, giving it more body. If the proportion of white to the colour is equal, the palette soon looks like an interior decorator's chart, with all the colours a pale pastel shade, lacking any contrasts of light and dark or softness and brilliance. To lighten red use yellow. White with red makes a cool pink.

The addition of black darkens the colour as well as its brilliance and care must be taken that it does not turn the colour to mud. (Delacroix said 'Give me mud and I will paint you a picture', but only the English it seems, with their brown mid nineteenth century paintings, took him seriously!) Care too is needed when mixing two complementaries such as orange and violet to obtain brown. Brown is a beautiful colour, especially when used by Rembrandt, but just how difficult it is to mix can be seen when visiting a national gallery that owns one

of his pictures and watching a student attempting a copy. Greys too are as beautiful as any colour and enhance those stronger colours against which they are placed.

Black and white alone have a large range of gradations; even more by adding umber to warm them or viridian to cool them; and by using reds and blues, such as alizarin crimson and french ultramarine to obtain violet or neutral greys, the permutations become almost limitless.

To return to the painting, our aim is to build up the picture, having by now established the general composition with its forms and values. We need to move into the lights, the half lights and the half shades. There will also be some half shadows on the edges of the dark cast shadows. We want to paint the volume of the objects and the spaces between and around them so that the hidden side of the water urn in this picture is expressed and the space around the small container so described that we feel able to pick it up. How is this done? Only by accurate observation of the relative strengths of the shades and the colours of the objects and their surroundings. In the case of the back of the urn it is the painting of the wall behind which is so important. And with the pot it will be the painting of the table. It is here that the use of warm and cool colour can be a help. Warm colours tend to come forward and cool colours to retreat. If the form of the urn needs more volume a touch of red could be introduced into the lighter areas. If the background was coming too far forward, giving the urn the look of

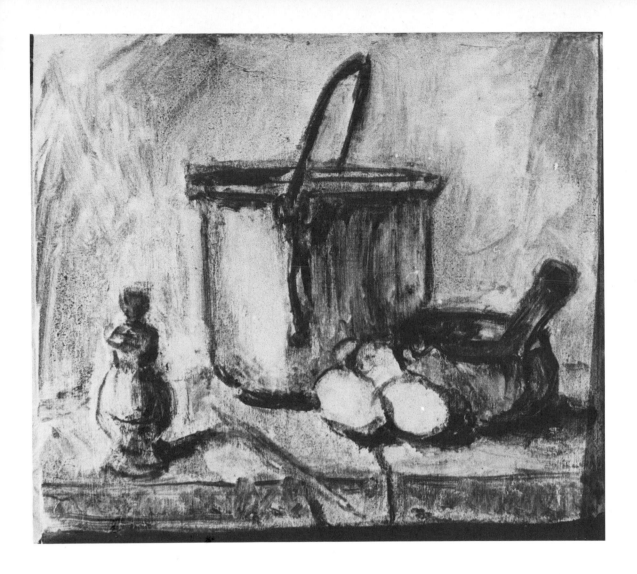

being paper thin, or two dimensional, then blue could be added to the background colour to push it further away. The edges of the urn too would be cooler since the edges we see are really only the horizons of the object, and it is beyond these horizons that one is painting in still life. We do this by placing one colour against another. That is the drawing of the picture, not by outlining and filling in, but by putting one brush stroke alongside another. It is in taking the painting beyond this stage that the ordinary painter parts company with the greater.

The second stage. An indication of the darkest values has now been made, and the drawing strengthened. The local colours have been washed on and the decision made to keep the cast shadows cool and transparent. They can be warmed later by glazing if necessary.

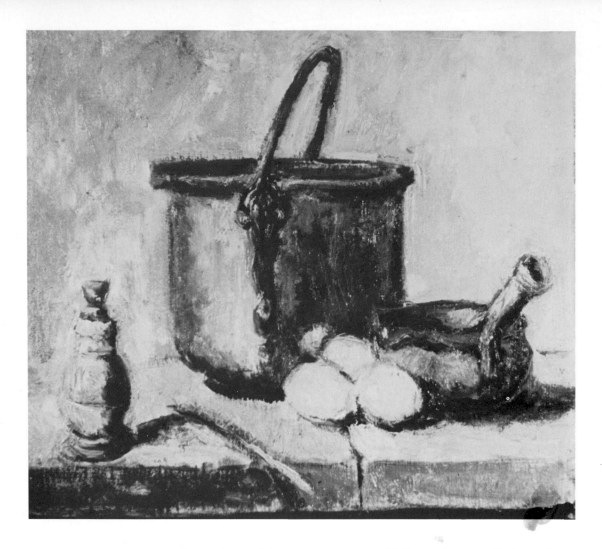

The painting has now moved into the crucial third stage when white has been added to the palette and the paint has started to become opaque. Thicker paint has been used to build up the lights, less thick the half lights and half shadows, and the darks have been glazed even darker, some cooler, some warmer depending entirely on the responses of one's eyes. A warm object, without a cool reflected light, and with a warm shadow, could prove too uncomfortably hot. It is these nuances of differing degrees of lights and darks, warmths and coolnesses that delight the connoisseur of fine paintings, and no one has more closely achieved these than Chardin and Cézanne.

The realizing of the modulations of the flat surface of the wall and the differing tints which can be seen against the darks of the urn, begins the final stage in this painting of quiet simplicity.

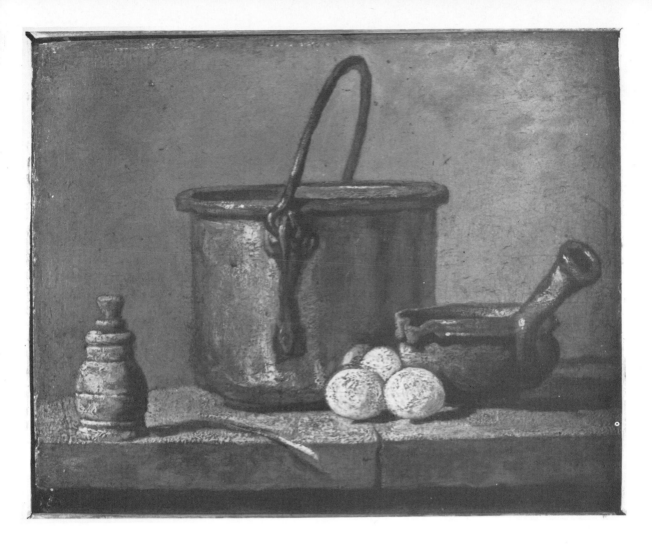

Jean Baptiste Siméon Chardin
Cooking utensils with eggs, oil on wood (*c* 1734)
43 cm × 53 cm
The Louvre, Paris

The finished painting in which the balance
between the lights and the darks, and the
form and the shapes has been harmoniously
achieved giving a picture of great calm and
comfort.

Detail of urn and background

How difficult the path is even for the masters can be judged by Chardin's *cri de coeur*, 'How many attempts, now happy, now unhappy'.

The search is on for the right colours, the right lightness and darkness and the harmonious juxtapositions of the colours. And by right, I do not mean cold exactitude, nor the photographic illusions of many *trompe l'oeil* paintings, but right in the sense of a poet using the right word. It is this poetry that cannot be taught. But by looking at nature and studying the works of the masters one can hope to move some way along the road.

I am never in a hurry to reach details. First and above all I am interested in the large masses and the general character of the picture. When these are well established then I try for subleties of form and colour. I rework the picture constantly and freely and without any systematic method.
Jean Baptiste Camille Corot (1796–1875)

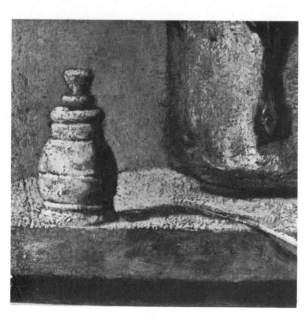

The little pot has been rendered as a solid volume in space not only by the shading on the object itself, but also by the gradations of tone applied to the table and the background; seemingly lighter against the darks, and more subdued against the brighter lit contours of the object.

Opposite page above
This alla prima painting of a pigeon was done on a 30.5 cm × 40.6 cm (12 in. × 16 in.) canvas which was only just large enough to contain the subject. It is therefore rather more in the nature of a study than a fully satisfying picture with a considered composition.

Opposite page below
A small painting 25.4 cm × 35.6 cm (10 in. × 14 in.) based on complementaries—the large green eating apples against the tomatoes and red peppers. I find after looking again at this picture after a lapse of some years that there is perhaps too much movement and too little rest.

Alla prima painting

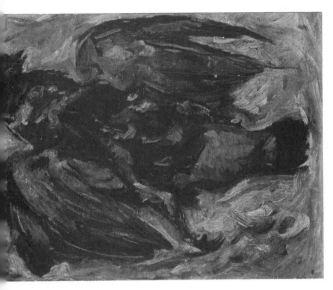

This is an exciting and stimulating method of painting particularly suited for the single, frequently transient subject, such as a fish or a bunch of flowers. It is also an excellent exercise in the handling of paint, calling for a quicker and freer execution than the slower and more thoughtful process just described. Nevertheless it is still necessary to design the object on the canvas, usually in such a manner that the subject fills the whole canvas. And for this the same approach, the thin wash drawing in with an appropriate colour is recommended; but, since the painting is to be completed in one sitting, wet on wet, more oil will be used to avoid the later applications drying at a quicker rate, resulting in cracking. When painting at this speed it is even more necessary to keep an eye on ones dipper to ensure it is still clean, and to change the vehicle frequently. The brushes tend to become overloaded in the excitement and a good supply of rags is important. Naturally mistakes are made and a palette knife should be used to remove the thicker paint. And finally, a word of warning and advice. So exhilarating has it been that one nearly always gets carried away and believes one has painted something good. Alas the sight of it next morning soon dispels this illusion of grandeur. I have learnt from many disappointments always to do a drawing at the end of the session, so that, sometime later when the painting is dry, I can make alterations; and though strictly speaking this is no longer alla prima painting it sometimes saves a canvas from the dustbin.

. . . but for adventurers as myself, I think they lose nothing in risking more. Vincent Van Gogh

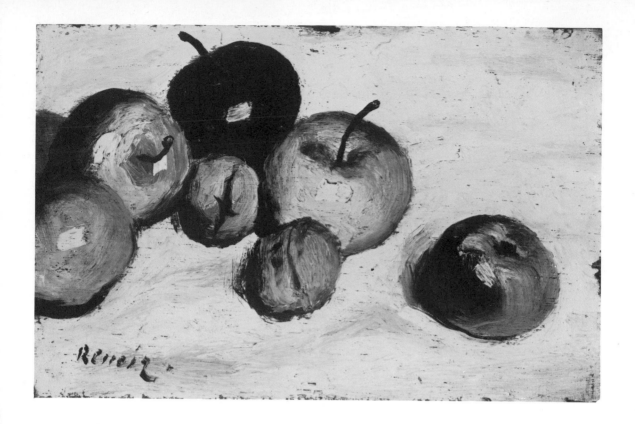

Pierre Auguste Renoir (1841–1919)
Apples and Walnuts
This little study by the great French
impressionist painter is unlike his usual way of
working in which the paint is stroked on
lightly with a sable brush. It is shown here to
illustrate the use of thick paint in the lights and
the use of brush strokes that follow the form
of the objects, a practice he inherited from his
early study of Courbet and the old masters.
There is here, too, a hint of Manet and his
peinture claire (page 90)
Fitzwilliam Museum, Cambridge

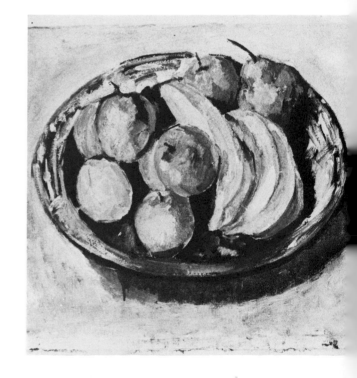

This group of pears and apples and bananas
was predominantly yellow and so I used
yellow ochre, lightened later by lemon yellow,
to wash in the initial design. The
complementary blue violet was used in the
shadows.

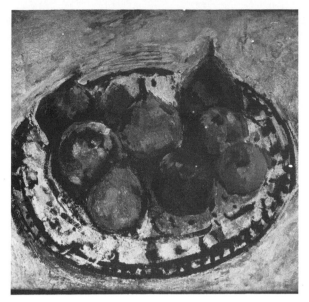

Terre verte, strengthened later by viridian and cobalt blue, was used here to start this alla prima painting of pears and apples.

This is not strictly speaking an alla prima painting, though it was intended to be so at the start. I found it impossible at one go to achieve the many subtle greys in these whiting, or to grasp their idiosyncratic forms and I did a number of drawings to help me understand their characteristics from which I worked later.

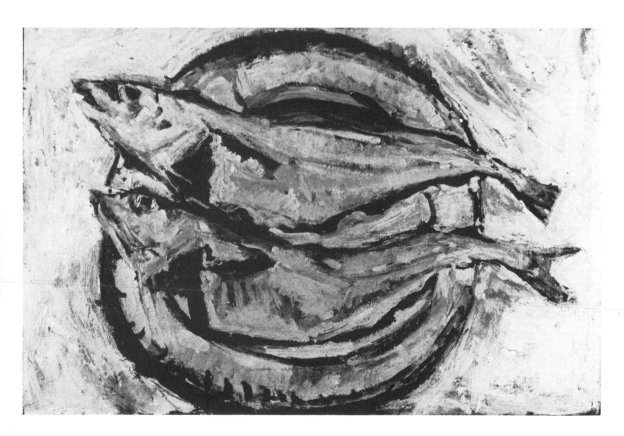

Example of bad painting

I would advise young artists to paint as they can as long as they can without being afraid of painting badly. Claude Monet (1840–1926)

I have chosen to reproduce a picture which I abandoned after a few days work, on the principle laid down by Sir Matthew Smith—that there is no greater immorality than in continuing to waste time on a picture that has been badly began. I will use it and its faults as a lesson in some 'dos' and 'don'ts'.

To start with the canvas chosen was too big for the group. At 76 cm × 61 cm (30 in. × 24 in.) it left many empty and uninteresting spaces, and more objects were somewhat arbitrarily added. A painting should have an air of inevitability, that nothing could be taken away nor added.

The design has been too rigidly constructed within a vertical and horizontal grid. Neither the left nor the right hand sides of the canvas contribute to the composition. The jug on the right has strayed too far from its neighbours, and the shadow it throws, which was intended to link it with the rest of the design, is unconvincing. The choice of utensils has not been particularly happy. There is a sameness about their shapes that is boring. Their placing is equally so. The base of the left hand dish is level with the base of the loaf of bread, (which incidentally doesn't much look like a loaf of bread to me). The same dish is also completely hiding the base of the large jug behind it. This is always an awkward thing to do, as one is left with no ellipse on the table with which to suggest its volume. The handle of the jug is inadequate, far too small for the size of the object. Even if it was that size in reality it should have been enlarged for the sake of the design and for the feeling of comfort everything should give. One must not slavishly copy what one sees.

The bottle is central, and though this in itself may not be wrong, it is too uninteresting a shape for its position in the picture. The brushes in the jar are the only diagonals and the painting would certainly look more restful without them. The whole arrangement has become an academic exercise and the lack of inspiration is all too apparent. The handling of the paint shows the mood of desperation that gradually grew as the painting progressed—the paint getting thicker in the dark where it should have been thin, and the source of light getting confused, now from the right and then from the left. An indecision over the surface on which the objects sit is evident. Is it a piece of cardboard or a piece of newspaper, or a piece of cloth? You can imagine that the colours are now beginning to get dirty, that the bottle is becoming dull green and that the other objects even duller browns and ochres. Some of the errors in this painting, which now appear obvious (but did not do so at the time I was painting) might have been noticed earlier if I had used a mirror. It is always advisable to look at your painting from time to time through a mirror as this gives you a fresh view of what you are doing. Bad drawing or wrong strengths of colour will immediately be apparent, just as they would be to a stranger walking into the studio and seeing the picture for the first time. Our own eyes can get tired and what is obvious to an outsider goes unnoticed by the painter.

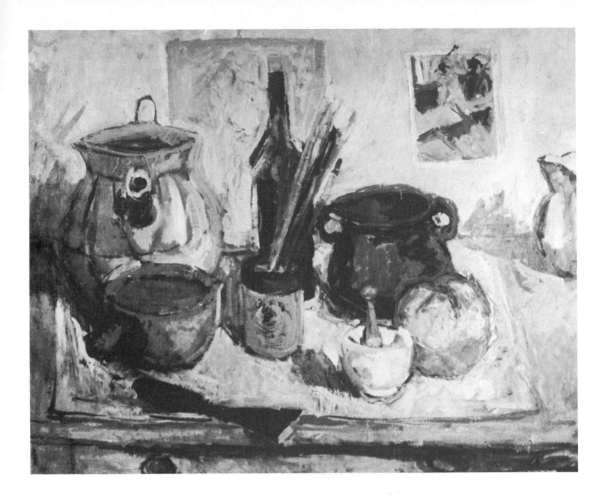

The abandoned picture 61 cm × 76.2 cm
(24 in × 30 in).

By reversing the image the mirror enables us to
re-see it. Nevertheless no picture, however bad,
has not been worth painting. We hope to learn
something from all our mistakes. Therefore
from this painting we can learn:

1 Care must be taken to choose a canvas of the
size best fitted for the subject we have set
up.
2 In setting up the group the rhythms
should continue all round the canvas, not
only in the outline of the objects against the
background, but also in the shapes they
make on both sides and in the foreground
of the canvas (page 99).

3 Choose objects of contrasting shapes and
sizes and textures which are yet
homogeneous.
4 Allow a little at least of the base of each
object to be visible.
5 Do not be afraid to adjust the design of an
object if by doing so the composition can
be improved.
6 If one has a central object it must have a
significant form to warrant its position in
the painting.
7 If one is using a grid, (in this case the canvas
was divided into nine parts, by two vertical
and two horizontals) do not stick too

rigidly within its lines. Whatever division of the canvas one uses it is only as a framework. So too with the geometrical construction of the composition. The use of the triangle, the pyramid and the golden mean can and must be moved by intuition.

8 Be positive about what you are painting. In this case the objects were standing on a piece of newspaper and that was not adequately stated. So often one sees landscape paintings in which one can not tell whether the trees are oaks or ash or elms. So in still life, the substance and character of the objects must be expressed.

9 If the paint starts to get too thick and the colours dirty, put the canvas away and let the paint dry. Continuing to paint wet on wet will only add to the damage.

10 Don't be afraid to start all over again. It is very commendable to try to get things right but there comes a moment when the puritan in us must be cast out. To make a fresh start is better, braver, and less pig-headed.

Finally, remember an artist must never be mean—either with his art or his materials. His drawing must be generous and flowing, his forms voluminous, his colours, however muted, rich. If his picture calls for thick paint he should pile it on, and he should not hesitate to scrape it all off again, if need be.

He who has not felt the difficulties of his art does nothing that counts.
Francisco de Goya y Lucientes (1746–1828)

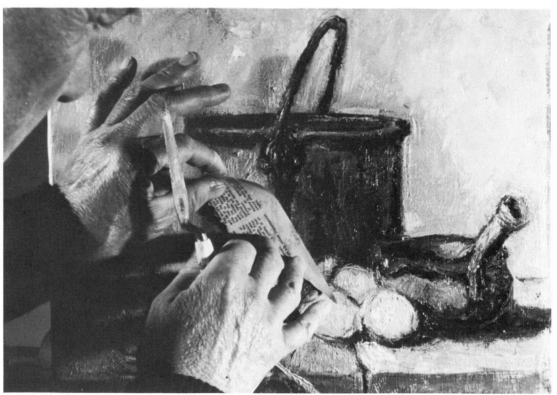

'Tonking'. Removing excess paint, first with a palette knife then by applying newspaper to the wet surface thus removing some of the oiliness but retaining some of the colour.

The finished painting

A moment comes when every part has found its definite relationship and from then on it would be impossible for me to add a stroke to my picture without having to paint it all over again. Matisse

The finished painting should not be varnished for at least six months—that is until the paint has thoroughly dried. However very thin paint can be varnished after three months. The object is twofold. First to protect the picture from dirt, secondly to restore the colour which may have gone dead as the oil evaporated. Retouching varnish can be used during the process of painting when the paint is dry to the touch, but it is not really to be recommended, as to my mind it gives the surface an unpleasant shine upon which to work. Colours sink mainly through ill-use. Over-painting when the first layer is still wet: too little linseed oil in the medium: and frequently dirty turpentine from a dirty dipper on an unclean brush. Similarly, if cracking occurs, it is because a quick drying layer has been placed over a slow drying area. The golden rule is to start thin, with quick drying washes using petroleum or lighter fuel as a medium and increasing the oil content towards the end. Pissarro who used a very dry touch left strict instructions that his pictures should never be varnished. Alas, one can seldom see a Pissarro these days that is not positively glistening under a coat of fresh varnish. If it is necessary to apply varnish, dust the painting, lay it flat and apply smoothly (avoiding air bubbles) with a fine hog hair brush, its size being dictated by the size of the canvas. There are a large number of varnishes on the market. No two experts seem to agree, as usual, on their qualities. However copal varnish is non-removable and darkens with age so it would seem inadvisable to use it. A well

recommended varnish is *Talens Rembrandt* made in Holland by Ludvicks, which is sold in gloss and matt finish, and should be used 2:3 gloss and 1:3 matt. The value of this varnish is that it can be removed (if necessary after twenty years or so) by wiping carefully with white spirit on a piece of linen or cotton wool. Make sure to look constantly at the pad for any hint of colour removal. One should never rub the paint surface. A good cleanser for dirty varnish only, and which will not remove it, is Winton's *Picture Restorer*, well shaken, applied with a squeezed out wad of cotton wool, and then wiped over with a well squeezed pad dipped in pure distilled turpentine, until there is no more dirt visible on the dabber.

Do not put any paintings away in a cupboard. Oil paint darkens when kept from the light, especially the darker colours, whilst the lighter become transparent. If you wish to remove the canvas from the stretchers in order to re-use them, roll the canvas painted surface outwards, to prevent cracking. Many pictures have been ruined by being rolled paint inwards. Remember, should the canvas remain rolled for too long, it would have the same effect on the paint as if it had been left in a cupboard. In that case, after unrolling, put the painting in bright daylight (not direct sunlight) for a week or so. It is also probable that the surface is dirty, in which case use Winton's *Picture Cleaner* as instructed above. Framing is always a problem, made more so by the fashions of the day. Many paintings in public galleries are so heavily overframed in ornate gold that they

45

distract rather than contain and isolate the picture from the background. Victorian paintings suffered especially from this handling. Many artists are not good judges on how to frame their own pictures, again preferring what is fashionable (and therefore easily available to buy and easier to sell) to that which is best for presenting the painting. Framing is an art in itself and a good framer is an artist in his own

right. Once framed most still life pictures can be hung with their centres at the average eye level of 1.4 to 1.6 m (4 ft 8 in. to 5 ft 4 in.) from the ground, against almost any background, whether it is wallpaper or a coloured surface. Curiously the latter is more likely to disturb the painting if the colour is incompatible than a multicoloured wallpaper of much intricacy, and patterning.

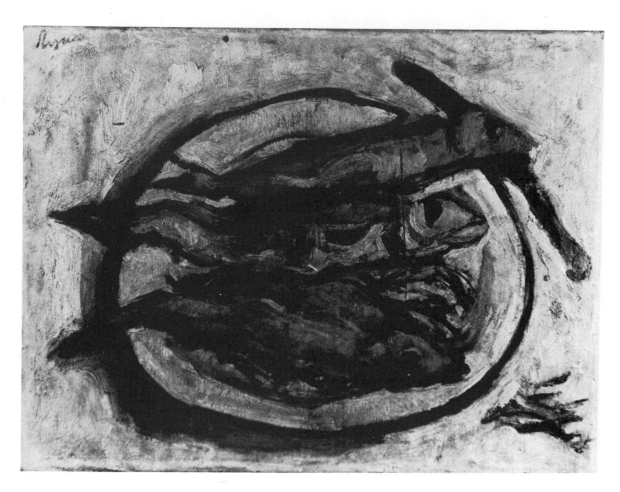

This little picture of fish and whitebait has been sadly neglected. It is dirty and damaged. The amateur should not attempt to restore a picture in this condition but should take it to a professional, if he can afford it; it won't be cheap. Most national galleries will give advice as to whom to approach, and will also tell you

whether the picture warrants it. Nevertheless, if you like a painting, regardless of its value, it is worth looking after. The large cut down the canvas can be mended without leaving any trace. Whatever you decide, do not wipe the canvas with a damp cloth, nor use a pealed potato to clean it, as was once practised.

Summary

How I often amuse myself when I am looking at a wall or a flat surface of any kind by trying to distinguish all the different colours and tints which can be discerned upon it—and considering whether these arise from reflections or from natural hues.
Sir Winston Churchill (Hon RA) (1874-1965)

I have tried to provide the beginner with sufficient information to start him off and with enough examples of still life paintings to encourage him to paint all the things around him. There remain no doubt many things still to say but perhaps just a few further words of advice and further repetition will suffice.

Choose simple objects to start with that do not present too complex a problem either in form or detail to paint.

Choose a single source of light, preferably from the right or the left so that you have a definite light and dark on the surface of the objects, and cast shadows that will help to explain their forms. This is important also should you be painting by electric light, since many rooms have several light sources. It is always preferable to paint by daylight but where this is not possible take great care with the use of yellow. This colour appears weaker under electric light and therefore one tends to overdo its use. A painting once begun in daylight should always be continued in daylight. So too if you start by electric light, continue the picture throughout by that source.

Experiment with your brushes and your brush strokes. Every painter uses them differently and many are recognized by the strength or delicacy of their touch. Some follow and emphasize the form, some use little dabs and others leave no brush marks at all, especially the photographic realists and the *trompe l'oeil* painters.

Paint the objects, wherever possible, sight size—that is the size they appear to you at the distance from where you are standing. Avoid painting anything larger than life.

Remember that glazing is dark over light and is kept transparent. Scumbling is light over dark, dabbed or stippled moderately dry over a dry surface, partially covering that surface with opaque paint. Both methods can be used to cool or warm the previous application of colour.

Always keep your brushes, palettes and dippers clean. Dirty paint is an insult to the medium and to the public.

Do not try to do everything at once. Build up your picture gradually and remember Delacroix's boast, 'I have the patience of an ox'.

You must learn by experience, however, when to stop. One can go on and on with a painting until in the immortal words of Dod Procter RA (1891–1972) 'the paint lies down and dies'.

Remember there always was, according to the critics and the experts, only one right way to paint, and always there came an artist, like Van Gogh, to prove them mistaken. But remember also that revolutionaries, such as Delacroix and Courbet, Cezanne and Matisse, were academics first, studying and copying the accepted Masters of their day. Its when you know the rules, that you can break them.

Your contribution will be your own vision and even though to you it may seem inferior to others one day someone may appreciate it. It is worth remembering that many a painting by an unknown artist has been rediscovered in some attic or antique shop and found to have

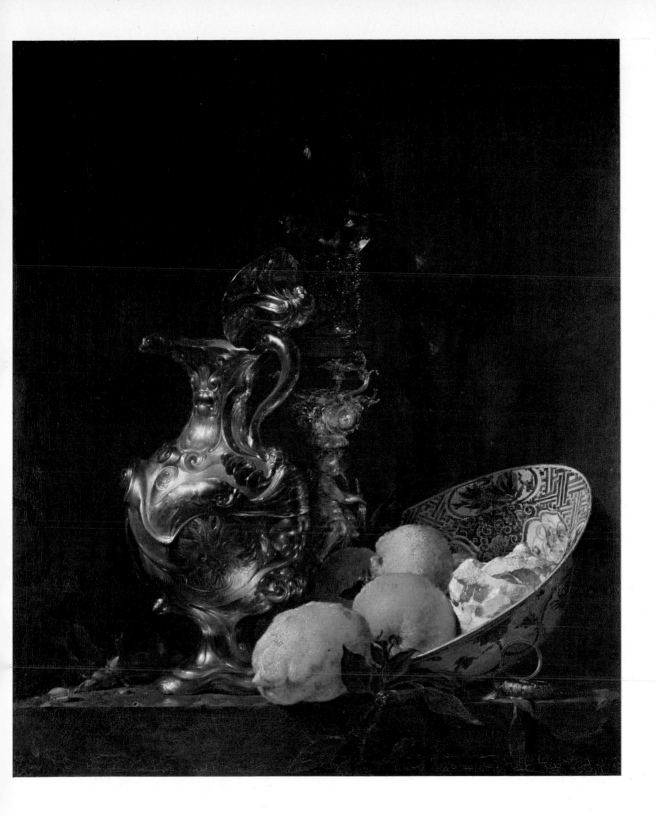

some aesthetic quality unrecognized at the time that it was painted. Many amateurs have achieved professional status, Gauguin for one. And many primitives, such as Henri Rousseau, have outlived the professionals who looked down on them. A painting done with a simple response by the painter to his subject will in many cases be more successful than an attempted intellectual conception.

And finally it is a fact that no two painters, whatever their talents, would paint the identical subject identically—man is not a camera. The object of painting is not to copy but to express one's delight in the colours, shapes, forms and relationships of the objects of one's contemplation.

And in a picture I want to say something comforting as music is comforting.
Vincent Van Gogh (1853–1890)

Historical background

The History of Still Life painting as a separate branch of art began in Europe in the sixteenth century. Until then objects appeared in paintings only as adjuncts to a religious story or as attributes to a particular saint. With the coming of the Reformation in the north, patronage in Holland and Flanders came not so much from the church as from the prosperous merchantmen of flourishing market towns and university cities. Freed from the need to tell a story that inspired faith, the artists were able to devote their talents to portraiture, to landscape and seascape painting, and to still life painting, of which the Dutch were to be the first great masters. No object was considered too humble to be painted and a wide range of subjects was depicted. They painted delicate flower pieces, and elaborate 'breakfast pieces', tables covered by many varieties of fruit, vegetables, and cheeses; and pictures of a philosophical or symbolistic nature, called *vanitas*, containing skulls and hour-glasses, candles and watches and other reminders of life's transience.

The Dutch had a great love both of nature and the home, and a passion for rendering the different textures of materials in the forms of silks and oriental carpets, Chinese porcelain and fluted glass. Their silversmiths and engravers produced an abundance of beakers and drinking horns, ewers and flasks, all of which were depicted in paintings known as *pronkstilleven*, or lavish displays. Rembrandt in the few still lifes he painted reversed the roles in which they first appeared, and made the figure but an adjunct to the object. See pages 59 and 60.

In the early seventeenth century Spanish artists began to paint their own forms of still life called *Bodegones* or kitchen pieces, more austere than the Dutch, in which vegetables and cooking utensils were painted under the strong light-and-dark influence of the Italian realist, Caravaggio. Still life painting was scarcely practised in England, Germany or Italy at this time, though Evaristo Baschenis was a notable exception with his paintings of musical instruments, while the *pronkstilleven* and the *vanitas* paintings continued to be popular in France.

In the eighteenth century the French artist Chardin painted still life with a richness of colour, with an architectural structure and with a dignity of presence that owed much to his love of the early Dutch Masters, but to which he added an especial quality of paint and tonal harmony that was both delicate and strong. It is doubtful whether his pictures in this genre have ever been surpassed.

Throughout Europe and North America, from the middle of the eighteenth century to the middle of the nineteenth century artists were almost exclusively occupied with portraiture, historical paintings and romantic landscapes. Still life was practically the preserve of so called primitive or amateur painters in the United States and Canada, and was still seldom practised in England, Germany or Italy; but occasionally painted with great brilliance by such masters as Delacroix and Courbet, in France, and by Goya in Spain. Towards the end of the eighteenth century in America,

where the accepted academic subjects were historical melodramas and political portraits, most notably by Benjamin West and John Singleton Copley, still life painting was fostered by Charles Willson Peale, the father of American art, and by his brother James and his son Raphaelle. This culminated at the end of the century in the *tromp l'oeil* works of William Harnett, John Frederick Peto, Charles King and John Haberle.

In the middle of the nineteenth century in Europe two French artists were also, but not exclusively, interested in the return of still life painting, namely Manet and Henri Fantin-Latour. The impressionist painters, such as Pissarro, Monet, Sisley and Renoir, who followed almost immediately afterwards were dedicated to the effects of light in a landscape and though all at one time or another painted still life, it was Cezanne, Van Gogh and Gauguin who felt the need to bring back a more formal construction in terms of form and shape to what was becoming increasingly ethereal. These three great painters lead the way into the twentieth century and heralded the birth of Cubism, Fauvism and Expressionism. Pierre Bonnard was to bring Monet's light indoors with paintings in which still life and people were finally united.

The paintings reproduced on the following pages have been carefully chosen and captioned to show the development of still life painting over the last four hundred years. Enlarged details show the different techniques used by the Masters from the various schools of painting both in Europe and America.

Dieric Bouts (*c* 1415–75)
Christ in the House of Simon oil on wood
40.5 cm × 61 cm
Bouts was an early Netherlandish painter who
was born in Haarlem but moved south to
Louvain where he spent most of his working
life. This is a particularly beautiful example of
still life used as an adjunct to a religious subject.
Still life was not to become an art form in its
own right until the next century.
Staatliche Museen Preussicher Kulturbesitz,
Belin (West), Gemäldegalerie

Jacopo de' Barbari (*c* 1450–1516)
The Dead Bird and Gauntlets
51.6 cm × 42.4 cm
A Venetian painter about whose early career
not much is known but who became popular
in Germany around 1500, where he also made
many delicate engravings. This painting is
generally considered to be the earliest known
still life. It is a subject that has been treated
many times since, and was particularly popular
in the Victorian era. (See also page 97)
Alte Pinakothek, Munich

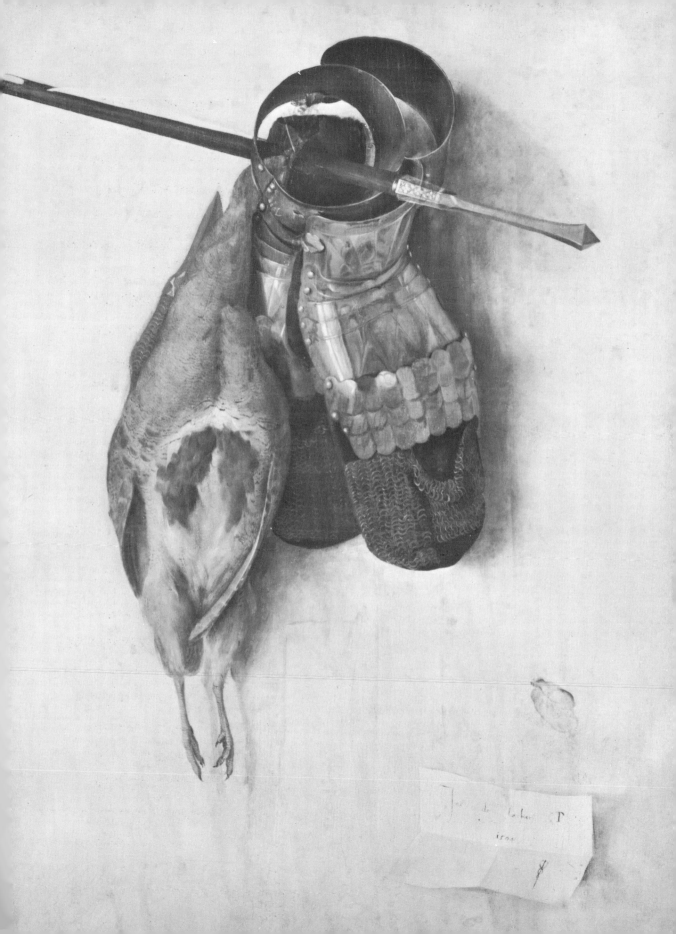

Jan Brueghel (1568–1625)
Detail of *Flowers* 125.5 cm × 96 cm
Jan Brueghel, known as 'Velvet' Brueghel,
was the second son of Pieter Bruegel the
Elder. He spent five years in Italy from 1590–95
before returning to Antwerp where he
collaborated with Rubens. He also painted
small brilliantly coloured landscapes but in a
very different spirit from that of his father.
However it was his flower pictures that gave
him a great reputation at the time. His many
followers and imitators have never equalled
the intricate quality of his work.
Besitzer: Bayer Munich

Ambrosius Bosschaert (1573–1621)
Flowerpiece 1619 31 cm × 22.5 cm
Bosschaert was a Flemish painter who, like so
many others, took refuge in Holland from
religious persecution in the South. More formal
and less extravagant than Brueghel in style he
remained Flemish in spirit throughout his
exile. His paintings and those of his three sons
had great influence on the Dutch. Painted on
copper, it has a luminous quality which, in
spite of the detailed manner, imparts a glowing
incandescence to the lights.
Rijksmuseum, Amsterdam

54

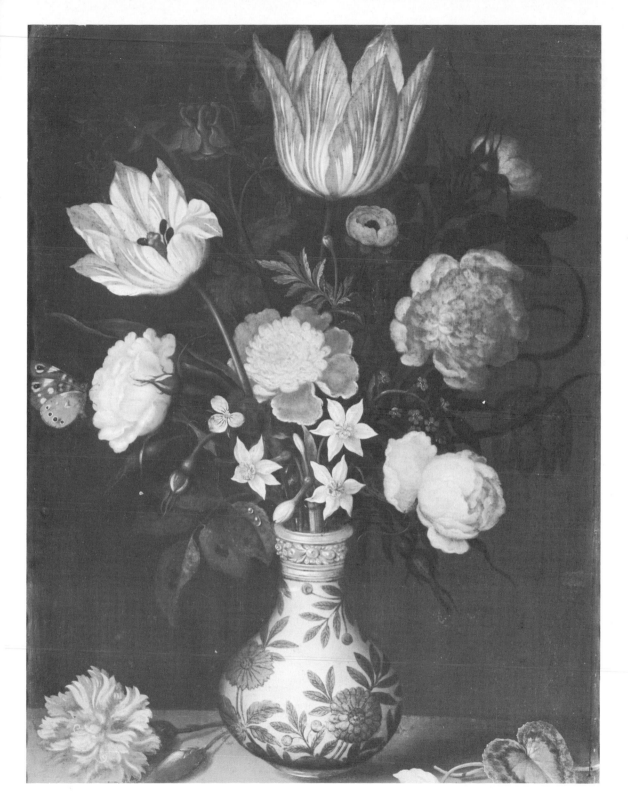

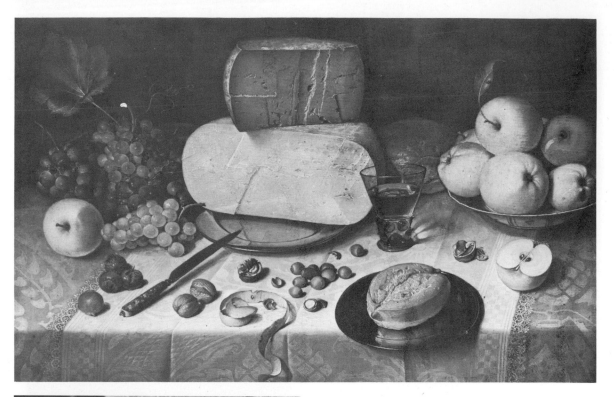

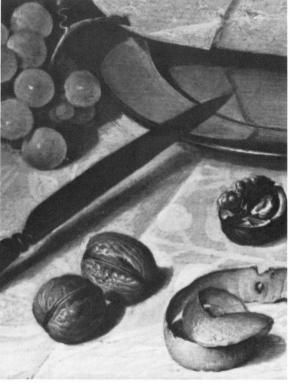

Floris Chaesz Van Dijck (1575–1651)
Still Life 1613 49.5 cm × 77 cm
Floris Van Dijck was born in Haarlem where
he lived and worked, though he also visited
Italy. His paintings are all of this special kind
of still life, known as Banquet pieces, in which
various forms of food and kitchen-ware are
piled high on top of patterned table cloths.
This picture, painted on panel, is one of his
less elaborate ones, but is still full of the
faithful detail and the illusionistic *trompe l'oeil*
that Dutch patrons demanded.
Frans Halsmuseum, The Hague
See also frontispiece

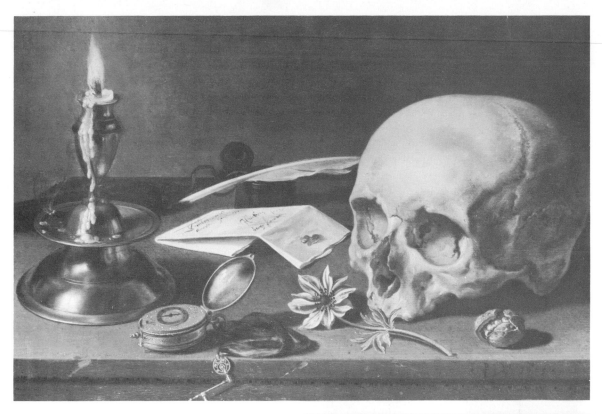

Pieter Claesz (1596/7–1661)
Still Life 30.5 cm × 43.5 cm.
A typical Dutch 'Vanitas' of the seventeenth
century. These paintings were much admired
in the University cities of Utrecht and
Leyden with their reminders of life's
transcience. The composition here is unusual,
with a central diminishing perspective. There
are also many uncomfortable moments where
one object just touches another, as in the
watchcase with the candlestick, and with the
edge of the will: so too the quill with the
skull. Such very close juxtapositions are
generally irritating and should be avoided.
Frans Halsmuseum, The Hague

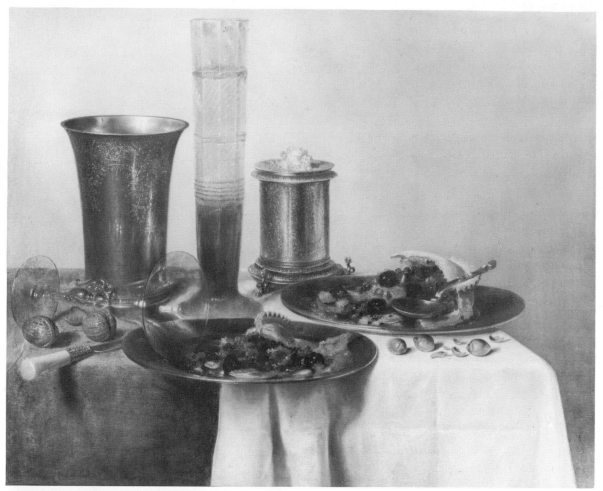

Willem Claesz Heda (1594–1682)
Le Dessert
Heda used much cooler colours than his Dutch
contemporaries, placing his objects against a
plain background and concentrating on the
realistic interpretation of surfaces. The apparent
emptiness of the right hand side is compensated
by the strong diagonal through the plates and
the subsequent return of the eye through the
triangle formed by the vessels.
Louvre, Paris

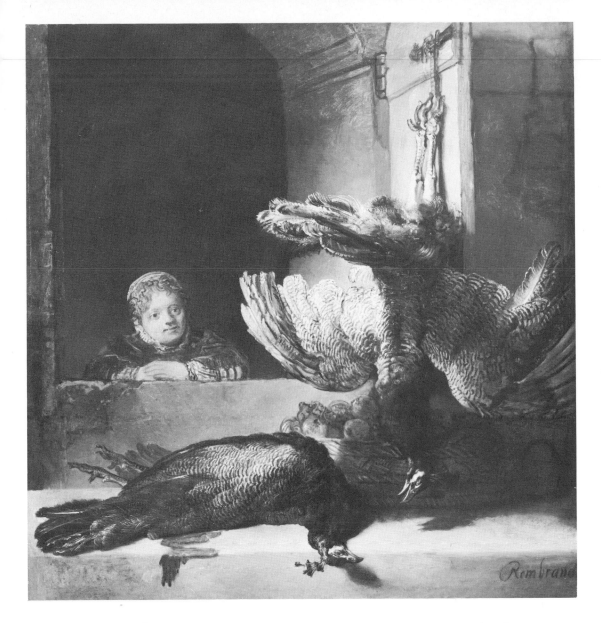

Rembrandt Van Rijn (1606–69)

Turkeys 145 cm × 135.5 cm

The greatest of all the Dutch painters of the
seventeenth century, Rembrandt painted only
a few still lifes. As with everything else he did,
he ignored what was fashionable and popular
in this genre, concentrating instead on
rendering the varying textures of his subject
matter and the effects of light and dark upon
them. His passionate interest in human beings
led him to study physiognomy, and the facial
expression on the young girl in this picture is
curiously enigmatic. His output was prodigious
and any attempt to describe it here would be
inappropriate; but attention must be drawn to
his remarkable use of paint, very heavy
impasto in the lights contrasting with thin
washes in the shadows, and to the way he
often worked the butt end of the brush into
the wet paint to express the surface of the
objects.

Rijksmuseum, Amsterdam

59

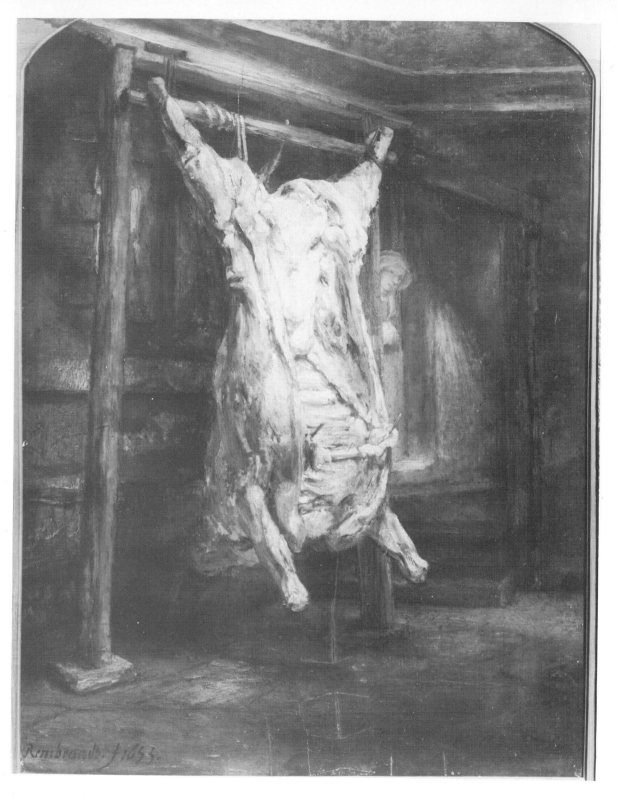

Rembrandt Van Rijn (1606–69)
The Flayed Ox, 94 cm × 67 cm
Rembrandt's most famous and most startling
still life still contains a little figure. In all his
hundreds of paintings, drawings and etchings
it is very seldom that Man is omitted.
Rembrandt was highly individualistic and his
chosen subjects were far removed from the
classical beauty of Renaissance art. In this
painting he seems to fuse and condense the
metaphysical preoccupation with life and death
that runs through all his great self portraits.
Louvre, Paris

Jan Davidsz de Heem (1606–84)
Detail of *Still Life* 26.5 cm × 41.5 cm
A Dutch painter who lived and worked in
Utrecht and Leyden before moving to
Antwerp where his breakfast pieces and
flowers became more extravagant and
Flemish in spirit. This is a typical example of
the kind of painting much appreciated in
university towns. Both Van Gogh and
Matisse among later artists, were to use old
books as subjects for their early work.
Rijksmuseum, Amsterdam

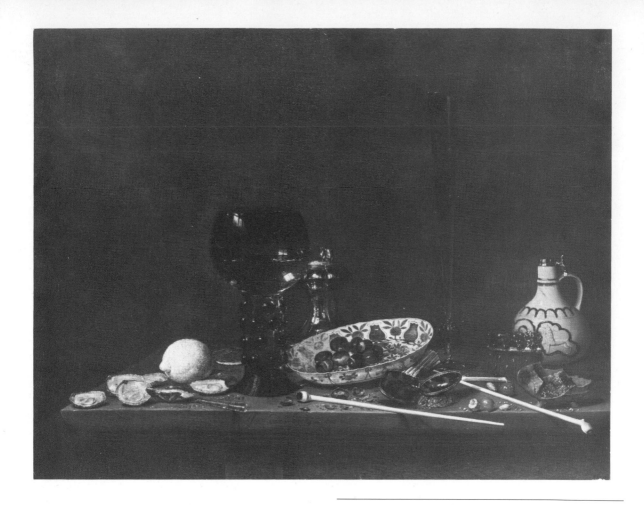

Jan Jansz van de Velde (1619/20–c 1662)
Still Life 69 cm × 89.5 cm
A Dutch painter of the Haarlem School not
to be confused with the marine painters of the
same name who came from Leyden and
Amsterdam. This poetic painting is the most
immediate precursor of the paintings by
Chardin a century later. There is a similar
homeliness about the objects chosen and the
same feeling of intimacy that Chardin evokes.
Rijksmuseum, Amsterdam

Barent Fabritius (1624–73)
The Slaughtered Pig 79 cm × 65 cm
Barent was the younger brother of Carel
Fabritius and together were pupils of
Rembrandt. Carel, (1622–54) who may have
been the master of Vermeer, died in the
Powder Factory explosion in Delft in 1654
and most of his work was lost. The influence
of Rembrandt on Fabritius can be seen in the
childs expression of wonderment, and the use
of strong lights and darks. The composition is
interesting with the carcass forming crossed
diagonals within an irregular diamond.
*Staatliche Museen Preussicher Kulturbesitz,
Berlin (West)*

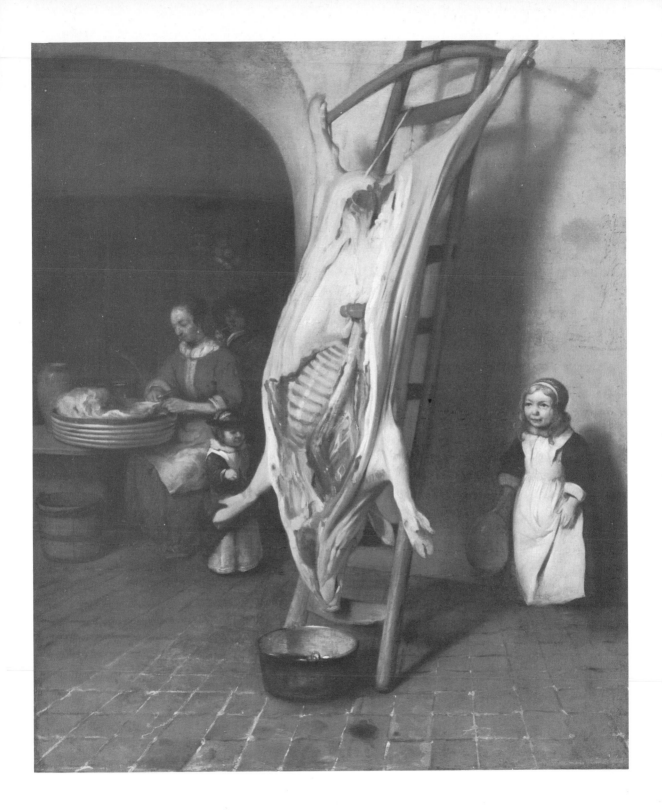

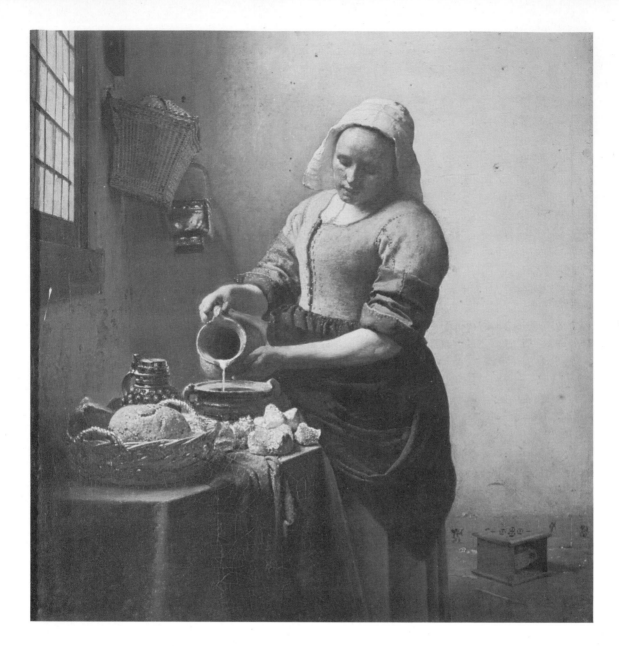

Johannes Vermeer (1632–75)
The Cook c 1660
45.4 cm × 41 cm
Vermeer remained largely unappreciated until two hundred years after his death. Among the first painters to understand the quality of his work were Pissarro and Van Gogh. One can see why—for in his use of paint to depict the light on the surface of differing textures, and by his application of that paint in thick jewel like spots, he anticipated the impressionist brush strokes and some of their aims. His pictures were however built up, layer upon layer with slow deliberation. He painted about 40 oils only, nearly all interiors with a single figure, and one glorious landscape of Delft now in the Maurithuis at the Hague.
Rijksmuseum, Amsterdam

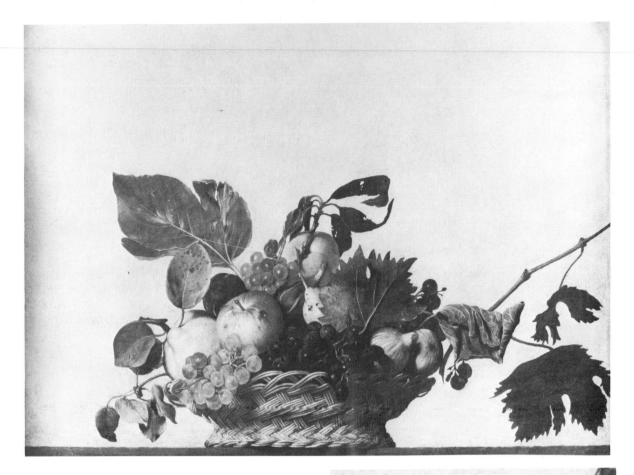

Michelangelo Merisi da Caravaggio
(1571–1610)
Basket of Fruit
An Italian painter of great realism whose use
of chiaroscuro was to influence many Dutch
and Spanish artists of the seventeenth century.
A pupil of a pupil of Titian, his early works
were mainly still lifes but he was later to paint
vast religious pictures for the churches of
Rome. A man of violent temper he fled to
Naples in 1606 after killing a man in a quarrel
over a game. His subsequent wanderings from
Naples to Sicily (where he was imprisoned
for assault, yet escaped to Malta) and back
again to Tuscany, did not prevent him from
painting large canvasses of ever increasing
simplicity and dramatic expression. His method
of direct painting without the customary
preparatory drawings was much criticised at
the time by the cognoscenti.
Ambrosiana, Milan

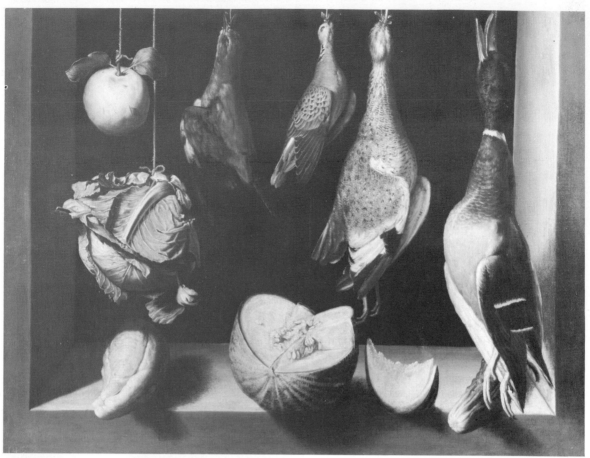

Juan Sanchez Cotán (1561–1627)
Still Life 67 cm × 88.3 cm
This is an extraordinary research into space,
almost surrealist in its unlikely juxtapositions
of hanging birds and hanging cabbage, the
slicing of the melon and the deep dark hole
in the centre of the composition. This picture
was painted about 1602, two years before he
became a Carthusian monk and devoted his
life to religious pictures. It is a very unusual
example of the Spanish Bodegones.
Art Institute of Chicago

66

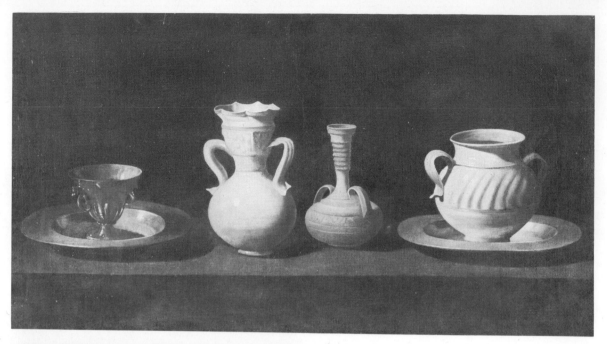

Francisco Zurbarán (1598–1664)
Still Life 18 cm × 33 cm
Like many Spanish painters of his time he
was influenced by Caravaggio, and later
developed a monumentally realistic style in
which religious figures were sculpturally and
serenely portrayed. This calm and
contemplative approach is very marked in his
still life paintings of which this is a particularly
haunting example. It has the simplest of
perspective designs: foreground, middle
ground, and background, based on a subdued
triangle.
Prado, Madrid

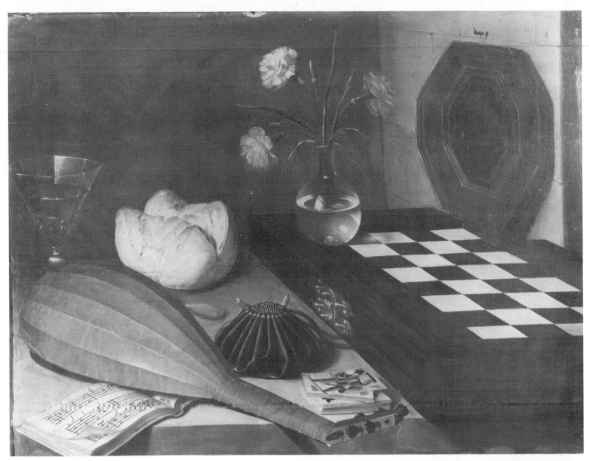

Baugin (fl. *c* 1630)
Still Life with Chess Board
A curious and disturbing picture, with its
symbolisms and exaggerated perspectives,
it was painted by an artist about whom very
little is known, except that he flourished in
Paris around the sixteen thirties. It has a
beautifully complicated composition and to
follow its parallels and diagonals and the
divisions within the canvas is like a game of
chess in itself.
Louvre, Paris

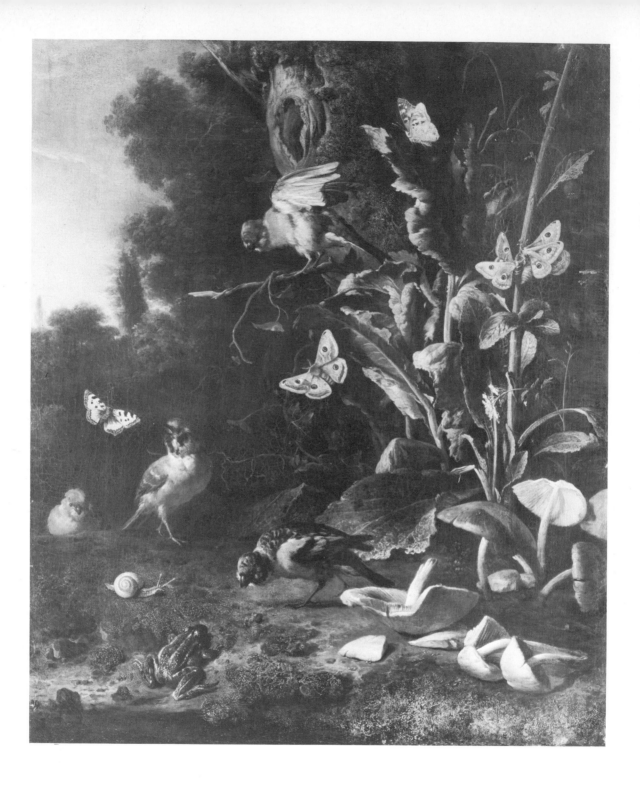

Melchior Hondecoeter (1636–95)
Birds Butterflies and Mushrooms
68.5 cm × 57 cm
I have included this beautiful painting, not
strictly speaking a still life, to encourage those
who like to paint natural history subjects. It
has been as carefully constructed as any
elaborate Dutch Still Life and just as lovingly
painted. His grandfather was a Flemish
landscape painter who moved like so many
others to Holland, living in Amsterdam till his
death in 1638. His father, Gysbert (1604–
1653) painted landscapes and still lifes; whilst
he himself concentrated on *trompe l'oeil* still
lifes and wild life studies. The American
painter Audubon (1785–1851) was his natural
successor. *National Gallery, London*

71

Jean Baptiste Siméon Chardin (1699–1779)
The Smokers Case c 1760-63 81.3 cm × 106.5 cm
One of the truly great academics in the world
of painting, he was the treasurer to the French
Academy for over twenty years and regularly
helped to hang its exhibitions. In this picture
the majestic calm of his objects is achieved by
his command of tone, that gives to each its
true volume in space. The composition is
deceptively simple, with the triangle formed
by the pipe, the jug, and the glass, set within
the golden section.

 Volumes I to VI of Lawrence Stern's
Tristram Shandy were published in the years
this picture took to paint and it is fun to
associate that great Francophile with Chardin's
serene observances of eighteenth century living.
Louvre, Paris

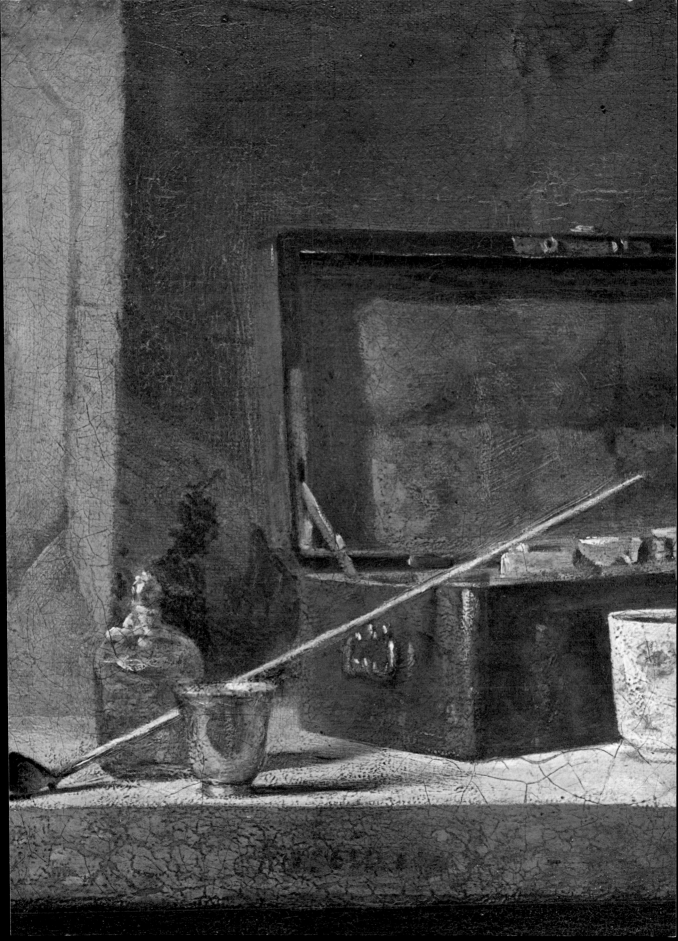

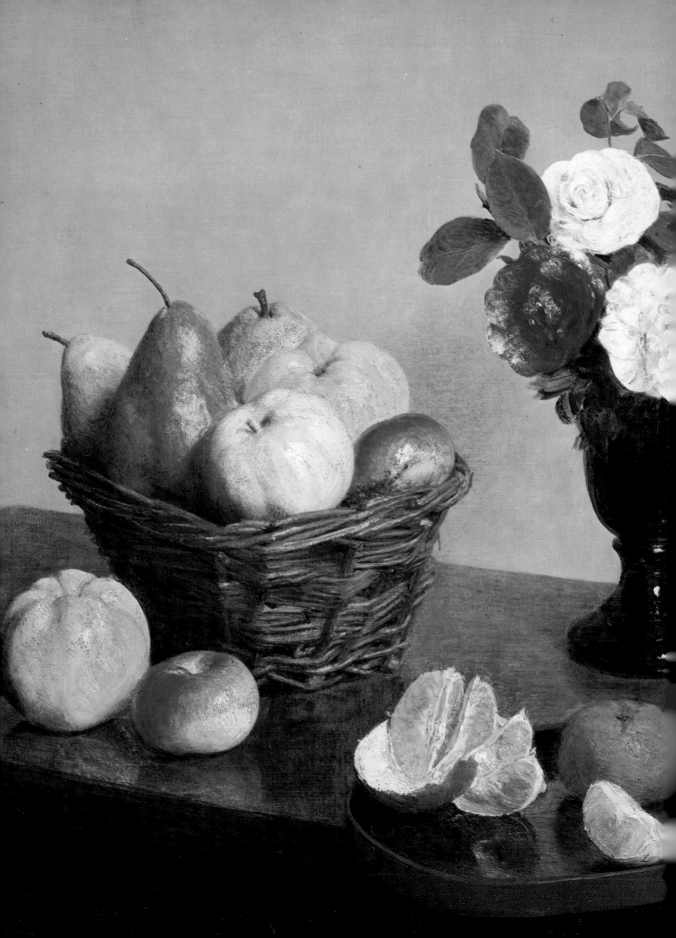

Jean Baptiste Siméon Chardin (1699–1779)
Preparations for a Lunch 1763
96.5 cm × 114.3 cm
A more complicated painting than the *Smokers
Case* but still the composition is laid primarily
upon a triangle whose apex is the top of the
plate, with its base line across the table top.
The verticals and horizontals that are stressed
fall either on the golden sections or on the grid
of three equal divisions
Louvre, Paris

◄**Henri Fantin-Latour** (1836-1904)
Detail (see page 91)

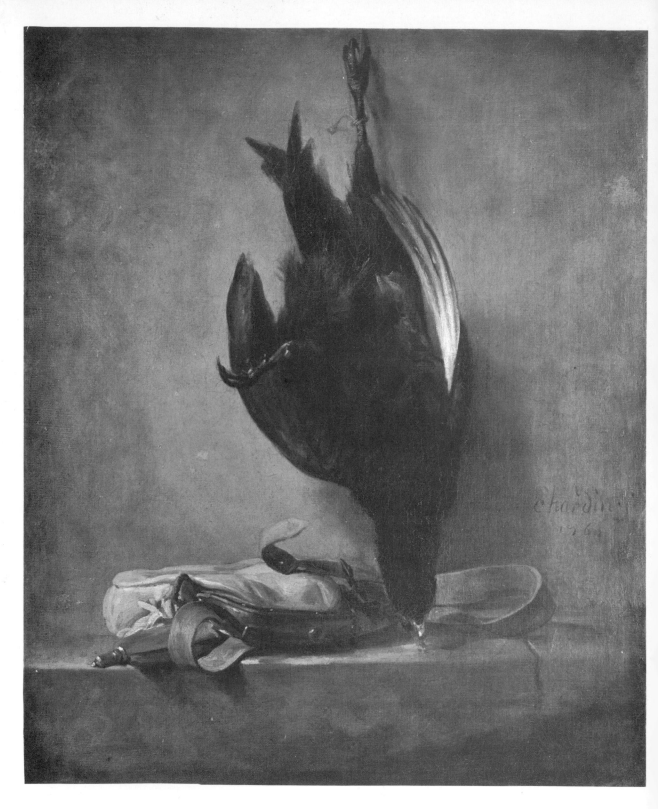

Jean Baptiste Siméon Chardin (1699–1779)
The Dead Bird
This recurrent theme, ever since the first still
life (see page 53) has continued to occupy the
attention of artists as much for study as for
any aesthetic or commercial reason. The
simplest of all triangular designs it stresses yet
again the inherent need for an artist to construct
his picture on a geometrical basis. Bonnard
wrote 'after drawing there comes equilibrium:
a picture that is satisfactorily composed is half
made.' See also page 97.
*Staatliche Museum Preussischer Kulturbesitz,
Berlin (West)*

Evanisto Baschenis (1617–77)
Musical Instruments
An Italian painter of meticulously composed
canvases, almost always containing musical
instruments. He delighted in the problems of
foreshortening, of light and shade, and, Dutch-
like, in the rendering of different textures.
Many of his pictures have an unusual amount
of dark empty spaces, almost hypnotic in the
shapes they form. Like many Italian artists he
was a priest.
Accademia Carrara, Bergano, Italy

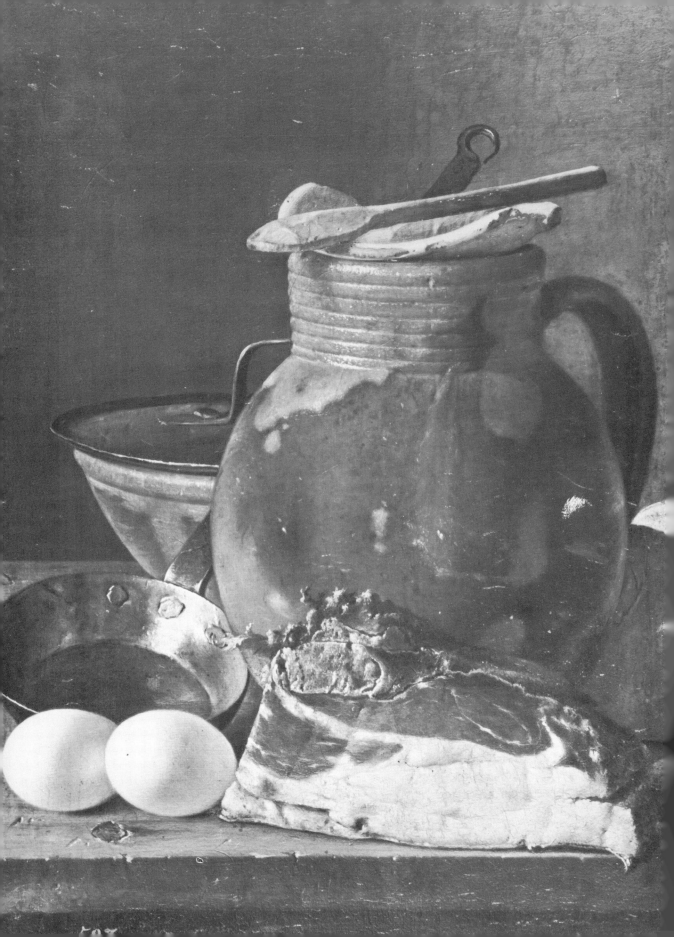

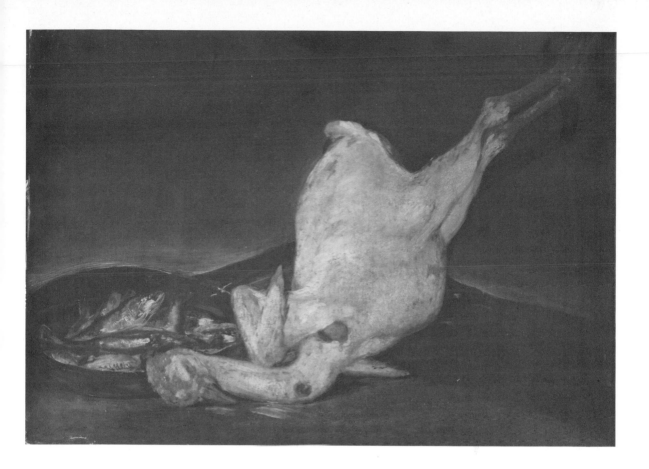

Luis Eugenio Melendez (1716–1780)
Ham, Eggs and Cooking Utensils
Melendez painted still lifes composed almost
exclusively of kitchen ware and food stuffs of
all kinds. He used a strong chiaroscuro and
fathfully depicted the physical qualities of the
objects. His pictures lack the feeling of space
and the serenity of Chardin's work but have
nevertheless a greater grasp of form than most
trompe l'oeil paintings of later schools, as well
as a greater degree of warmth toward the
subject matter.
Prado, Madrid

Francisco de Goya y Lucientes (1746–1828)
The Plucked Chicken c 1820 44.8 cm × 62.4 cm
Goya, the great Spanish master, painted only a
dozen still lifes, mostly of dead game, poultry,
fish and meat. Two notable examples are the
Butchers Table in the Louvre, and the *Calf's
Head* in the Museum of Art, Copenhagen.
This picture is an example of a very simple
composition based on the single diagonal, with
a triangular design formed by the lines of the
table, to keep our eyes from straying outside
the canvas. However instinctively one paints
every picture must have a considered
composition upon which it finally rests. There
is no such thing as an uncomposed picture by
a Master.
Alte Pinakothek, Munich

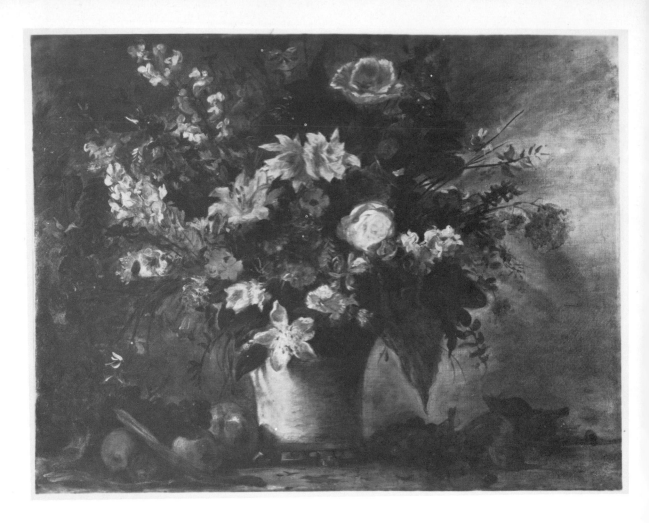

Ferdinand Victor Eugène Delacroix
(1793–1865)
Flowers
Delacroix spent his early years copying the
paintings of the old masters, particularly those
by Rubens in the Louvre: here he met the
English painter Bonnington, who introduced
him to the works of Constable and other
English painters, some of whom he much
admired when he visited England in 1825.
From then on he lightened his palette and a
journey to Morocco in 1832 led to an even
more brilliant use of colour. His handling of
paint became freer, in contrast to the then
fashionably classical manner of Ingres and
David. This flower picture is a glorious
example of his technique and his exuberant
love of nature. A similar painting in the
National Gallery in London was previously
owned by Degas and then by Renoir, who
himself was much influenced by Delacroix's
use of colour and paint. Delacroix's journals
give a vivid account of life in Paris in the
middle of the nineteenth century and of his
own manner of working.
Kunsthistorisches Museum, Vienna

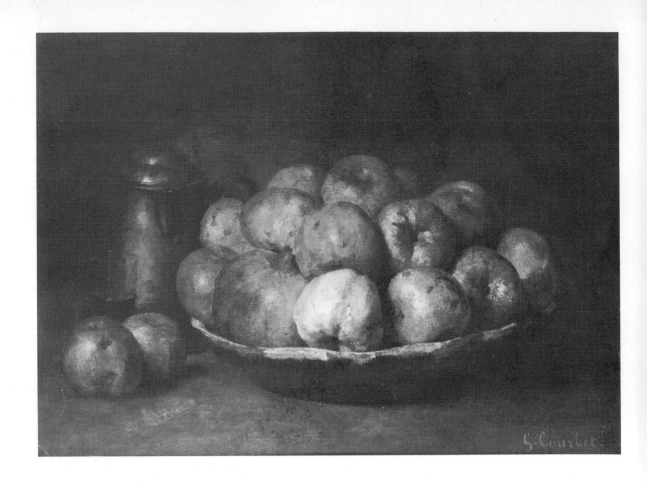

Gustave Courbet (1819–77)
Apples and a Pomegranate
44.5 cm × 60.6 cm
This is a wonderful example of the way a still
life painting is built up in the traditional
manner—layer upon layer, thin in the darks
and thick in the lights. This great French
realist painter rejected both the classical and
romantic art of his time (as personified by
Ingres and Delacroix) for a naturalism based
upon everyday life. He covered a vast range of
subjects from the humble still life to giant
canvasses of peasants and workers. He was as
much ridiculed and lampooned in his lifetime
for his vigorous handling of paint and his use
of the palette knife, as for his revolutionary
incursions into politics.
National Gallery, London

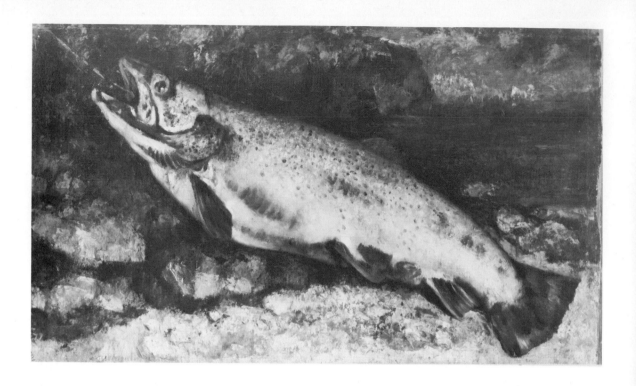

Gustave Courbet (1819–77)
The Trout 1871 55 cm × 89 cm
Courbet claimed to have painted this and other
similar studies of trout whilst in prison for
the part he played in the destruction of the
Napoleonic Column in the Place Vendôme in
Paris. The quality of the paint is difficult to
convey in a reproduction but it has a tactile
beauty akin to that of Rembrandt's. He has
based this single object painting on the simple
diagonal.
Kunthaus, Zurich

John James Audubon (1785–1851)
Ivory-billed Woodpeckers 99.7 cm × 66.7 cm
oil on canvas
Audubon was born in Haiti of French parents
and was educated in France where he studied
painting under the classical French painter
Jacques-Louis David (1748–1825). Returning
to America in 1807 he made his living as a
taxidermist, making hundreds of drawings of
birds and other wild life. These were eventually
published as 'Birds of America', and
'Quadrupeds of America' with many hundreds
of plates, constituting one of the most splendid
monuments to a man's love of nature. As with
the painting by Hondecoeter (page 70) the
construction of this picture has been carefully
considered, this time upon an upright triangle.
This feeling for composition is an intuitive
instinct in all painters and draughtsmen who
design within a rectangle. Many such designs
are ambiguous and can be analysed differently
by every spectator—but the result of their
analysis will always be order and not chaos.
Metropolitan Museum of Art, Rogers Fund 1941.
New York

John Johnston (1753–1818)
Still Life 1810 oil on panel
37.1 cm × 46.1 cm
This comparatively early American painting is
a fine example of how movement can play a
dramatic part in a subject so quiet as a still
life. By emphasizing the ragged edges of the
vine leaves and by using the branch of the
bunch of grapes as a strong diagonal in the
composition, the artist has added excitement to
an otherwise commonplace setting.
St Louis Art Museum

Unknown American Primitive
Flowers and Fruit 1830 76 cm × 57 cm
This is one example of the many still life
paintings by untutored or naïve artists that are
to be found in the United States. They were
frequently painted from instruction books by
young ladies using oils and water colours on
paper and fabrics, often with the help of
stencils; and many were embroidered with silk
thread on linen by the very young. Highly
stylized and skilful they reflect a way of living
that was prosperous and leisurely before the
days of the industrial revolution.
National Gallery of Art, Washington
Gift of Edgar William and Bernice Chrysler
Garbisch

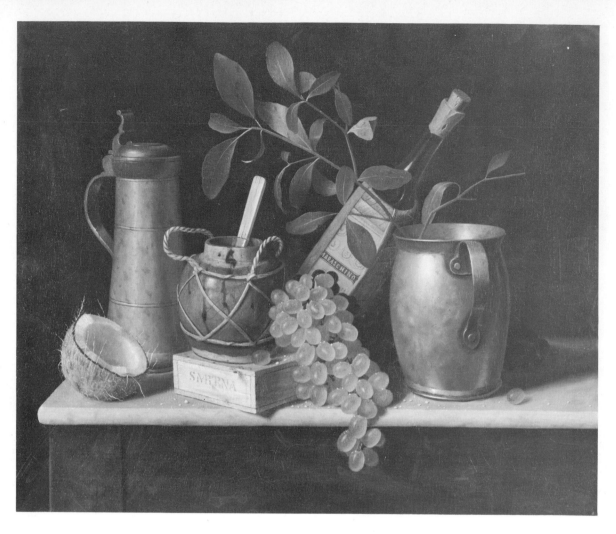

William Harnett (1848–92)
Just Dessert 1891 56.5 cm × 68 cm
Harnett was an American painter of Irish birth
who carried on the tradition of careful realism
founded by the Peale family of Philadelphia.
The extraordinary care taken to depict the
different substances, and the strange lighting
that illumines the objects give this picture a
curious surrealistic air. Of all the American
painters of still life this skill comes closest to
equalling that of the Dutch painter Floris Van
Dijck. See page 56.
*The Art Institute of Chicago Friends of American
Art Collection*

Charles King (1785–1862)
The Vanity of the Artists Dream 1839
89.5 cm × 74.9 cm
This painting by one of America's earliest still
life painters is less restricted in its use of
accessories than the 'Vanitas' pictures of the
seventeenth century. It is more in keeping with
the artistic tastes of the nineteenth century
public, about whom Saki (H. M. Munro)
wrote 'they leaned towards the honest and
explicit in art—a picture, for instance, that
told its own story—with generous assistance
from its title'.
Fogg Art Museum, Harvard University,
Cambridge, Massachusetts, gift of Grenville L.
Winthrop

John Frederick Peto (1854–1907)
Old Time Letter Rack
America is rich in artists of the *trompe l'oeil*
school of painting, one of the best of whom is
John Frederick Peto. His paintings of clearly
defined objects within a stylistic design have
become, after years of intellectual neglect,
much sought-after pieces and now receive the
attention of those who formerly ignored him.
His paintings have a poetic quality that
succeeding generations of painters in this
manner seem to lack. As in many paintings
however, time may lend enchantment to the
scene.
Courtesy of bequest of Maxim Karolik, Museum
of Fine Arts, Boston, Massachusetts

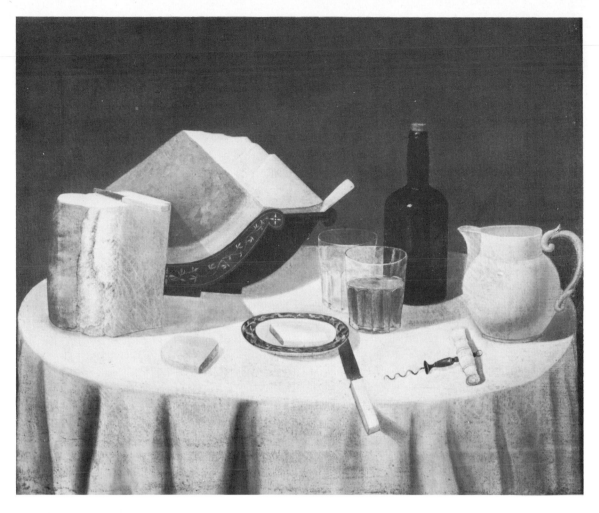

M. B. Higginson (*c* 1869)
Still Life, inscribed 'Painted Madeley,
Staffordshire 1869 51 cm × 62 cm
A naïve painting by an English so-called
Primitive, it shows all the characteristics of the
amateur painter—that is, a formal arrangement
usually inflexibly full-faced, and with emphasis
on detail and a subsequent loss of true
proportion. Each object is lovingly depicted
and holds great interest for the social
historian. The Stilton cheese is resting in a long
since abandoned cheese holder and the handle
of the corkscrew contains a brush for dusting
the bottle!
Courtesy of Dr D. Pratt of New York

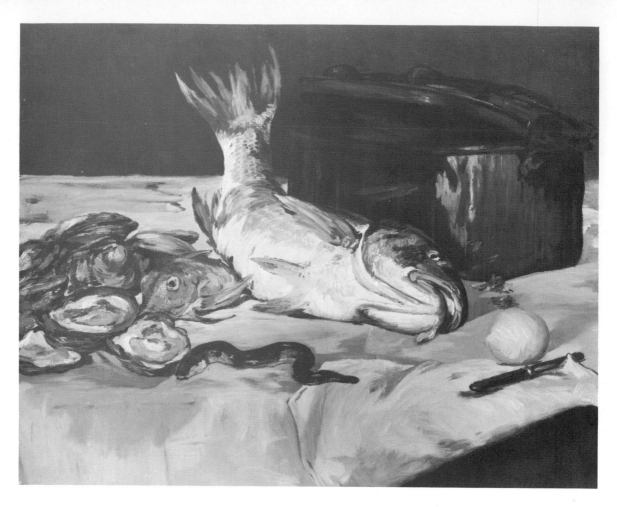

Edouard Manet (1832–83)
Still Life with Carp 1864 73.3 cm × 92.1 cm
This is an example of Manet's 'peinture claire',
painted directly from the subject with great
urgency, using thick pigment throughout and
employing a pre-impressionist palette in which
black played a major part. It shows the
influence the Spanish painters Velasquez and
Goya had on his early work, with their
realism and strong contrasts and brilliant
handling of paint. Later he was to adopt the
impressionist's approach and palette, but he
remained nevertheless a lonely academic, the
last of the great nineteenth century
traditionalists.
Art Institute of Chicago

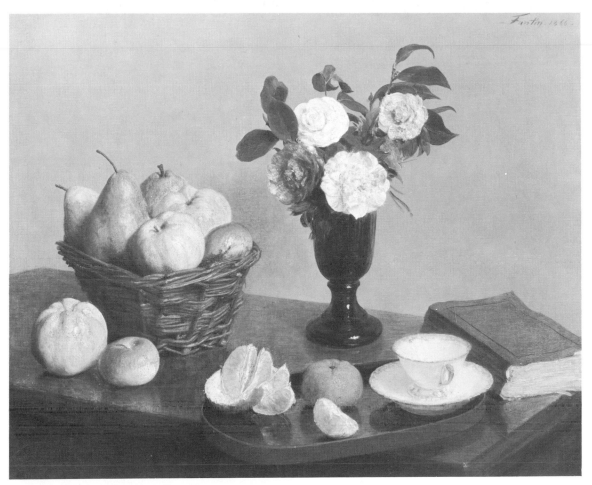

Henri Fantin-Latour (1836–1904)
Still Life 62 cm × 74.8 cm
A French painter of diverse interests, he
painted large academic portrait groups,
romantic figures in a post-Delacroix manner,
and many flowers pieces and still lifes, the latter
with a faithful allegiance to the Dutch
seventeenth century Masters. These are always
a joy to discover in some public gallery with
their calm and tender account of nature and
their rendering of so many different
substances.
*The Chester Dale Collection, National Gallery of
Art, Washington*
See also colour plate facing page 73

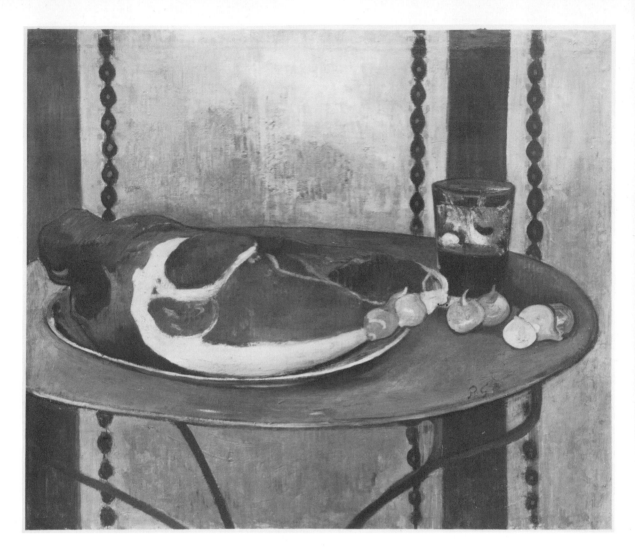

Paul Gauguin (1848–1903)
Still Life with Ham 1889 50 cm × 58 cm
One of the most remarkable adventurers in
the field of art, Gauguin gave up his career as
a prosperous broker to devote himself entirely
to painting at the age of 36. At first influenced
by Pissarro and the impressionists with whom
he exhibited, he later moved away from their
representational approach towards a flatter
more decorative and more arbitrary use of
colour. This picture was painted after an
abortive visit to Van Gogh in Arles and before
he left Europe for the South Sea Islands where
he was to paint his great landscapes and figure
compositions.
The Phillips Collection, Washington

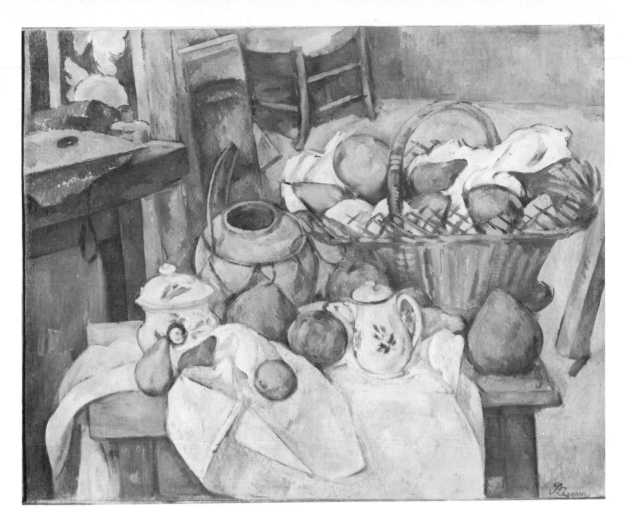

Paul Cézanne (1839–1906)
Still Life with Fruit Basket 1886–88
65 cm × 80 cm
Cézanne, like Gauguin (1848–1903), described
himself as a pupil of Pissarro. He exhibited at
the first impressionist exhibition of 1874 a
canvas totally unlike those by which he is now
known. It was an erotic fantasy entitled
'Modern Olympia' painted with impasto and
applied by palette knife, and was received with
great indignation by the public. However,
under the influence of Pissarro he started to
paint directly from nature using the
impressionists' palette. He became less
interested in their preoccupation with the

fleeting effects of light on surfaces and more
concerned with the structural form of nature
and objects.

A too literal reading of this painting would
detract from the enjoyment one receives when
seeing it for the first time. The apparent
impossibility of there being room on the table
for the very large basket of fruit as well as the
ginger jar, the other fruit and the coffee pot,
is due to Cézanne's habit of introducing
several eye levels and different perspectives
within one picture. This was to lead, twenty
years later, to the cubist experiments of Picasso
and Braque.
Louvre, Paris

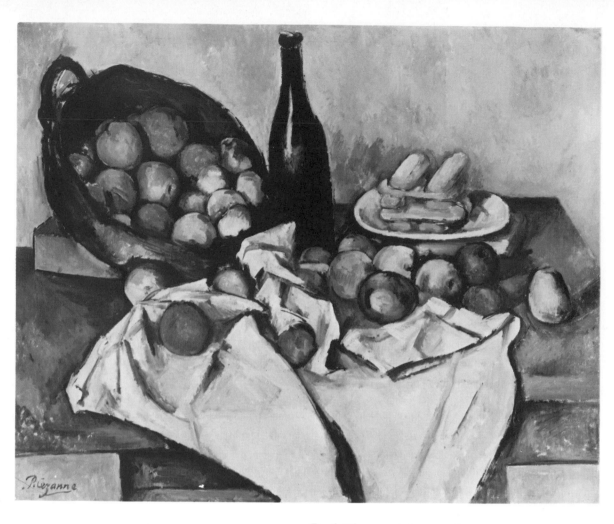

Paul Cézanne (1839–1906)
The Basket of Apples c 1895
61.9 cm × 78.7 cm
This is one of Cézanne's late still life
masterpieces in which he has fully realized his
analysis of forms in space. Less complicated in
construction than the painting in the Louvre,
(page 93), the composition is based on the diamond
shape with the additional strengthening of the
design at the golden mean where the bottle
meets the basket. So many changes of direction
occur in the act of painting that it is impossible
to know whether the diagonals and stresses are
instinctive or purposely classical, in keeping
with Cézanne's avowed intention 'to do
Poussin again from nature'.
*The Art Institute, Chicago, The Helen Birch
Bartlett Memorial Collection*

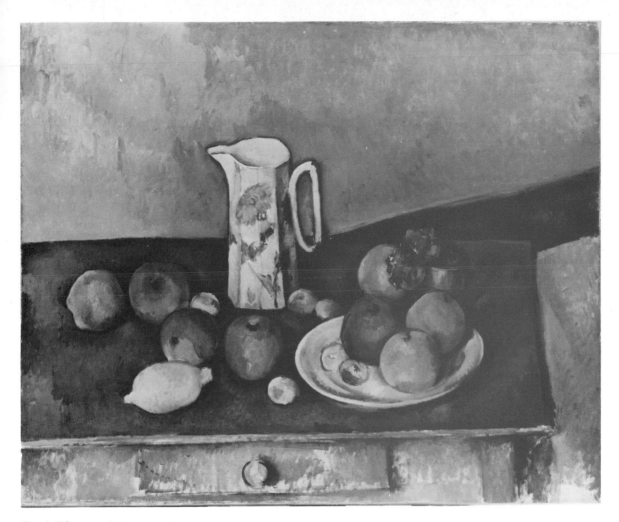

Paul Cézanne (1839–1906)
Still Life with Jug 1888–90 59 cm × 73 cm
By painting in touches of small wash-like brush
strokes for a considerable time in the build up
of the picture, and by avoiding laying in an
overall wash of the local colour, Cézanne left
many small areas of canvas uncovered. Such
was the difficulty of the task he had set
himself, and such his integrity, that he
frequently found he was unable to put down
the exact harmony, and rather than make an
approximate attempt he would leave the canvas
bare.
National Gallery, Oslo

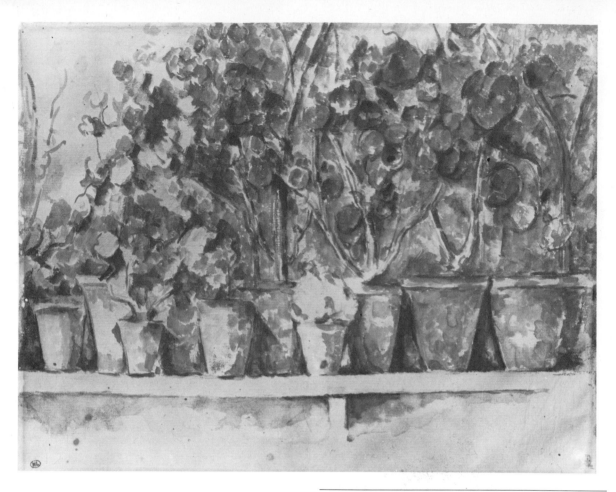

Paul Cézanne (1839–1906)
Les Pots de Fleurs water colour
23 cm × 30 cm
Cézanne's water colours are built up in the
same way as his oil paintings, with many
hesitant outlines, small washes of colour and
early development of his darks. He would use
body colour whenever he needed to, and often
squeezed colour direct from tube to paper.
His early romantic approach never entirely left
him.
Louvre, Paris

William Beales Redfern (1840–1923)
Still Life with Pheasant 1872 water colour
45 cm × 38 cm
This Victorian water colour by an 'unknown
artist' was found in an antique shop in London
and purchased for a few pounds. A little
research found that the artist was a pupil of the
animal painter J. F. Herring Junior. The
composition of this accomplished painting is
based on the pyramid. Such rewarding finds
are not all that rare if one enjoys hunting in
second-hand shops and looking into auction
rooms.
Courtesy of Mrs Peter Green's Collection

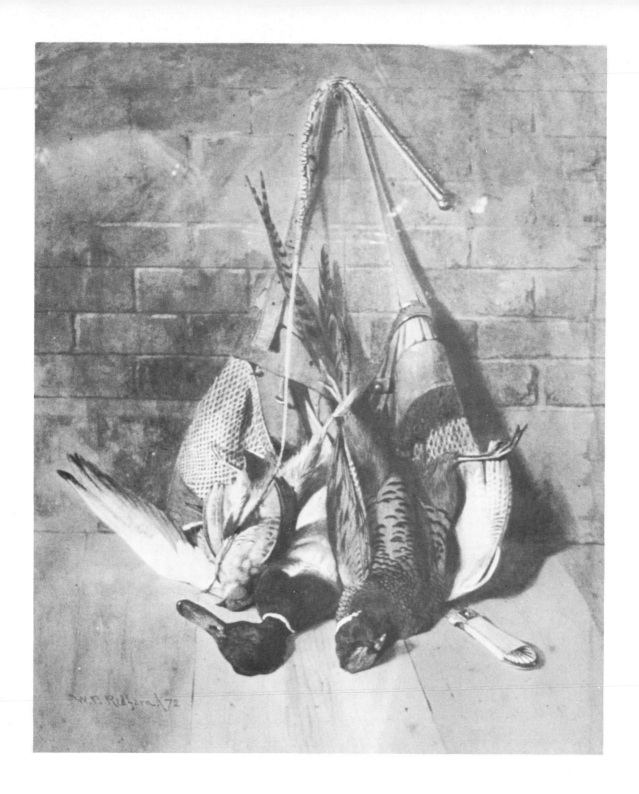

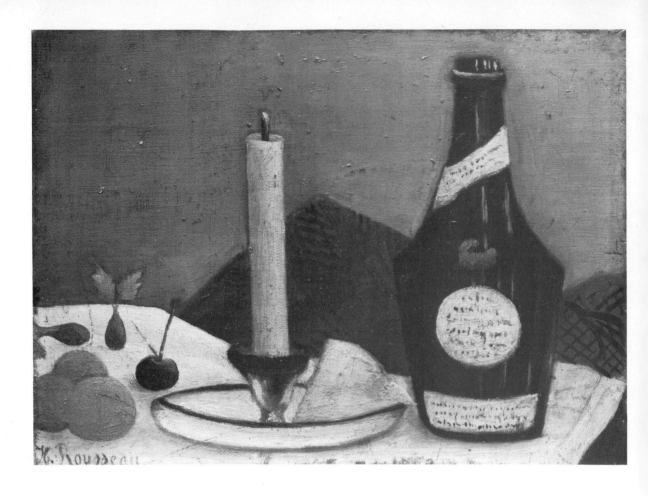

Henri Rousseau (1844–1910)
The Pink Candle c 1905–8 16.2 cm × 22.2 cm
This unique French painter is not as simple a
soul as this picture seems to imply. After a
humble upbringing and a few years spent as a
musician in the army of Emperor Maximilian
in Mexico (a questionable claim he made in
later years, though he certainly served in the
army from 1863–8 and again in the Franco-
Prussian war of 1870–1) he took a civilian job,
first as a lawyer's clerk, and then as a minor
inspector in a custom house, or toll station,
on the outskirts of Paris. It was this
employment that gave rise to his nickname
'Le Douanier'. Although he had probably
drawn and painted a little all his life, his earliest
pictures date from 1880 when he was thirty-
six. Self taught, or rather untaught, his work,

like many of the American primitives whose
pictures he may have seen in Mexico, have a
child like quality and an ingenuousness of
character that endeared him at the time to a
wide circle of artists and intellectuals,
including Renoir, Toulouse Lautrec, Picasso,
and Apollinaire.

In 1885 he retired from his post and spent
the next twenty-five years painting exotic and
imaginative jungle pictures, (there is a
particularly fine one in the National Gallery
in London) as well as landscapes of Paris and
its outskirts. Though these, and his small
preliminary sketches, have a remarkably
accurate tonal quality, they continue to
reflect the Folk art heritage with which he
started.
The Phillips Collection, Washington

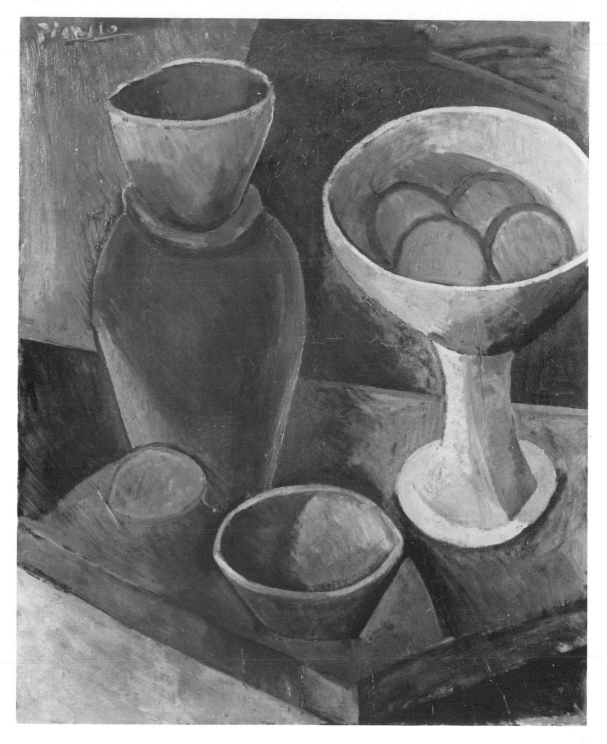

Caption overleaf

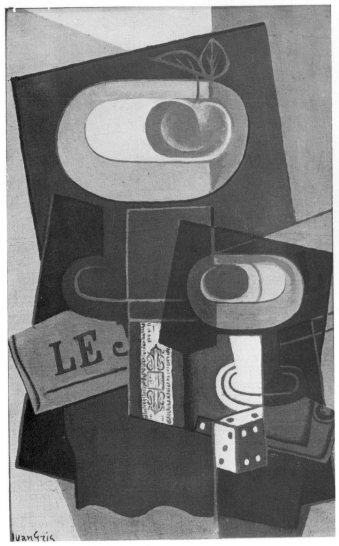

Juan Gris (1887–1927)
Still Life with Dice 1922
Juan Gris was born in Madrid and studied there
at the school of arts and crafts before leaving
for Paris at the age of 19. A natural
draughtsman and with a scientifically based
education he brought to cubism a classical
purism and an intellectual logic. His paintings
have a calmness and a reflectiveness that
distinguishes them from those of Braque and
Picasso and aligns him with Chardin. He was
to continue his analytical study of the form of
objects in all their facets until his early death
at the age of 40.
Musée d'Art Moderne, Paris

Caption to page 99
Pablo Picasso (1881–1973)
Bowls and Jug 1908 81 cm × 67 cm
The beginnings of Cubism are evident in this
still life with its concern for construction and
its intellectual analysis of form. The varying
eye levels and the resulting inconsistency of
ellipses foreshadow the later development
when all reference to natural light disappears
and forms are broken down into geometric
fragments.
*Philadelphia Museum of Art, the A. E. Gallatin
Collection* Copyright SPADEM 1977

Juan Gris
Three Lamps 1910–11 water colour
61.8 cm × 47.8 cm
An early example of the cubist movement
where the form is still depicted
atmospherically, and with a definite source of
light. The cubists were to abandon this
approach in their analysis of objects, seeking to
express their forms on a two dimensional
picture plane without the use of tonal
perspective. This in turn led to the use of
several view points of the objects and the need
to be able to see through them. It could be
said that cubism was the father of abstract
painting.
Kunstmuseum, Bern

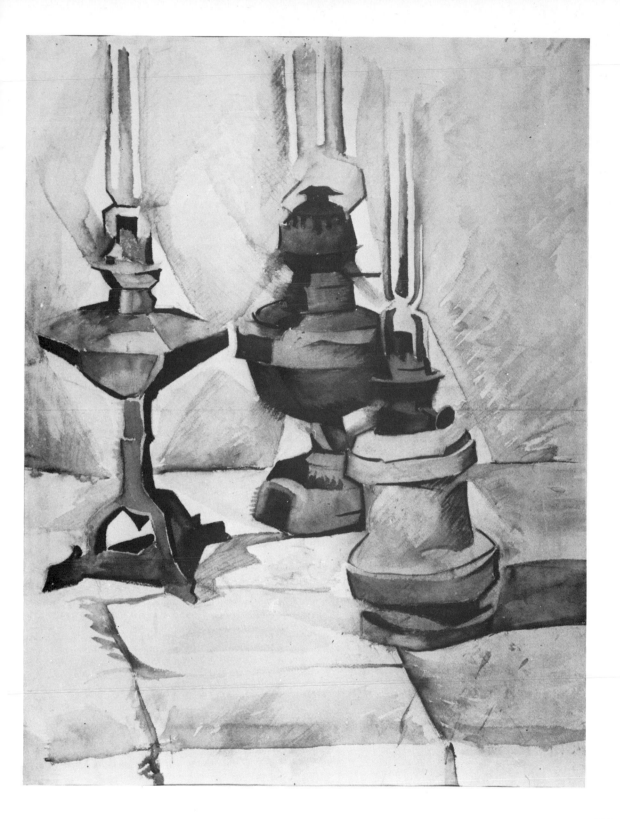

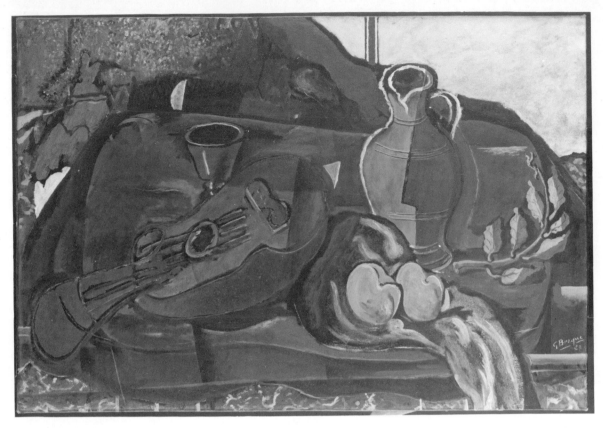

Georges Braque (1882–1963)
Guitar and Jug 81 cm × 116.5 cm
After an academic training at the Ecole des
Beaux Arts in le Havre and then in Paris,
Braque exhibited with the Fauves in 1907,
painting in intense colours pictures of the
South of France, but with an increasingly
evident influence of Cézanne. At the same time
Picasso in Paris was moving through the
influence of African art, towards the structural
quality of Cézanne's work. Together Braque
and Picasso developed a new aesthetic approach
to painting, largely expressed in terms of still
life, which became known as Cubism. Musical
instruments made a reappearance as subject
matters in many hundreds of beautiful still
lifes by Picasso, Braque, Juan Gris, and their
many followers.

This is a much later example than the ones
by Gris and Picasso reproduced here, and shows
the decorative ends to which Braque put their
more austere beginnings.
Tate Gallery, London
Copyright SPADEM 1977

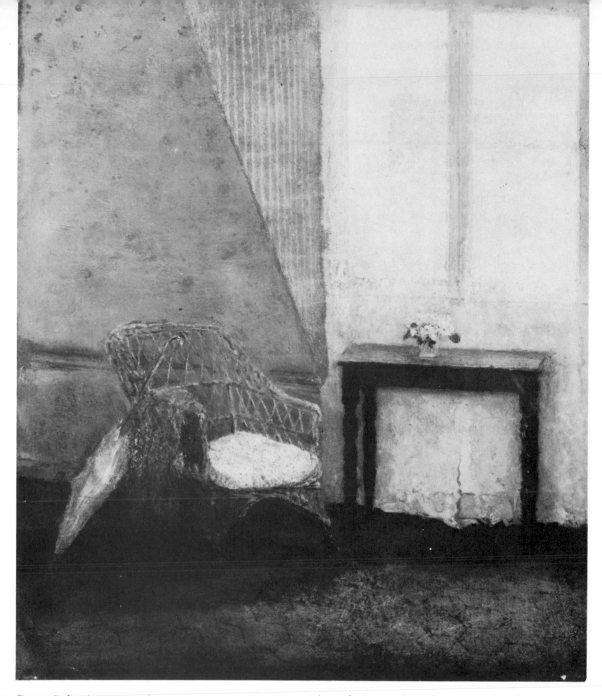

Gwen John (1876–1939)
A Corner of the Artists Room in Paris 1907–9
31.7 cm × 26.6 cm
This picture was painted in Paris, where she
lived for most of her life, at the time of great
artistic excitement in that city. Gwen John was
to continue so to paint for the next thirty
years, unmoved by modern movements, living
in reclusion, and producing works of
compelling simplicity of form and colour. Her
younger brother, Augustus John, who was
undoubtedly the finest portrait painter of his
time, described her as 'the greatest woman
painter of this or any age'.
*Graves Art Gallery by permission of the City of
Sheffield*

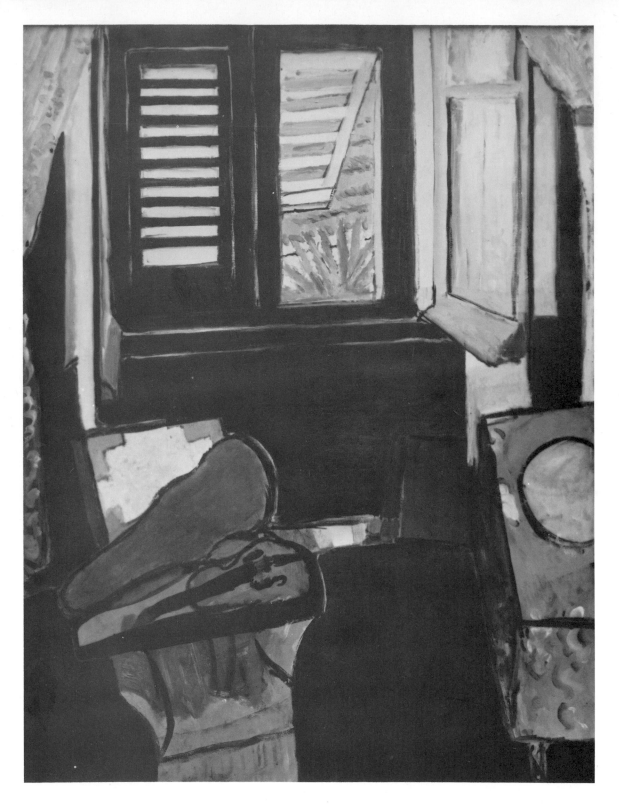

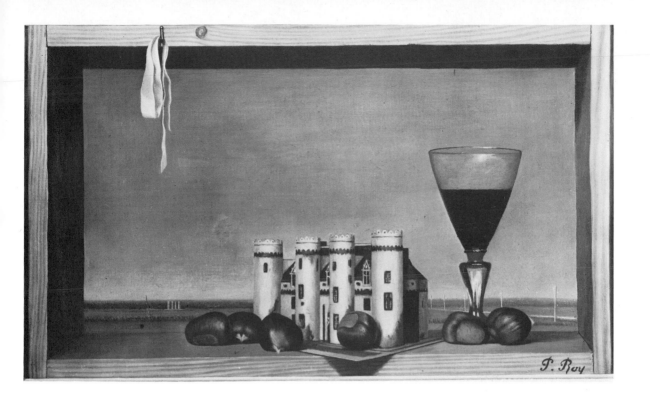

Henri Matisse (1869–1954)
Interior with a Violin 1917–18
116.2 cm × 88.9 cm
I have chosen this painting, out of the great
many still lifes Matisse painted, for two
reasons. First, as a contrast to the quiet painting
by Gwen John; and secondly to show how, in
both instances, still life painting can include
more of the surroundings, and place less
emphasis upon the single object, opening up,
I hope, a wider horizon for the beginner.
Matisse, like Picasso, was one of the great
innovators of twentieth century art, and as with
Picasso, I shall not attempt to describe the
many sided output of his activities. However
it is worth pointing out that every painting
was subject to constant refining, and there was
in all his work no hint of accident.
Royal Museum of Fine Arts, Copenhagen
Copyright SPADEM 1977

Pierre Roy (1880–1950)
L'Ete de la saint Michel c 1932
A surrealist painting which combines the real
with the subconscious, the possible with the
impossible, and uses the *trompe l'oeil* technique
to confuse the onlooker and to add to the
mystery of the image. Surrealism flourished in
the nineteen twenties in the years following
Cubism, and like so many movements in the
art of this century was dominated by the
genius of Picasso.
Musee d'Art Moderne, Paris

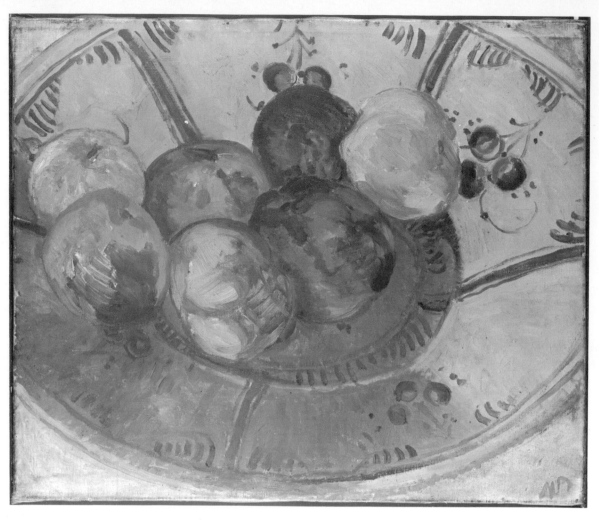

Sir Matthew Smith (1879–1959)
Apples on a Dish 47 cm × 54.5 cm
All alla prima painting by England's most
exciting artist of the first half of this century.
He studied for a short time in Paris under
Matisse during the Fauvist period, but soon
developed his own very rich and personal
colour range in a series of still lifes and
opulent nudes. He also painted many
beautiful landscapes of Provence in the South
of France.

 This is a picture in which the eye level is
directly above the object, and the task of
expressing form is at its most difficult.
Tate Gallery, London

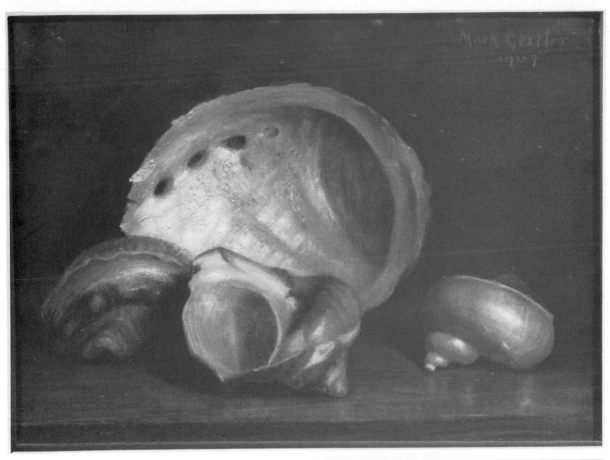

Mark Gertler (1892–1939
Sea shells 1907 42 cm × 50 cm
This painting by one of England's best Jewish
painters of his time is a remarkable study by
a fifteen year old of the mother of pearl quality
of shells. Gertler was a keen collector of
antiques and bric-à-brac and painted many
still lifes of his cherished *objets d'art*.
Like his fellow Jewish contemporaries in
France, Modigliani, Soutine and Pascin, he died
tragically at an early age.
Fitzwilliam Museum, Cambridge

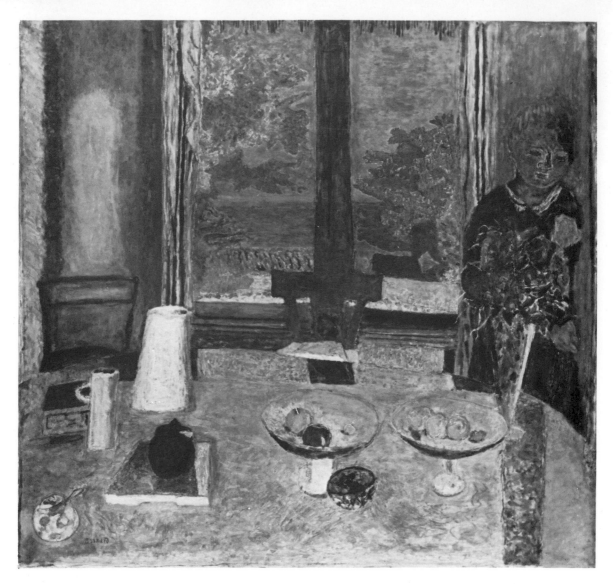

Pierre Bonnard (1867–1947)
Dining Room on the Garden (before 1933)
126 cm × 134.6 cm
Bonnard was one of the most beautiful
colourists of this century, with a staggering
combination of harmonies throughout his
paintings. In his long life he spanned the years
between Gauguin with his followers, the
Fauves with their use of flat and violent
colour, and the wilder antics of the abstract
expressionists. Throughout his life he pursued
what Van Gogh called 'the marriage of form
and colour'. This is but one example of the
many still life paintings in which he seems to
have achieved the ultimate in uniting still life
painting with the human figure. He also
painted vast landscapes of the South of France
that are as moving as the last water lily
paintings of Claude Monet. He led a quiet
uneventful life and left a great volume of work,
much of which depicts his wife, eternally it
seems, in and out of her bath.
Solomon R. Guggenheim Museum, New York
Copyright SPADEM 1977

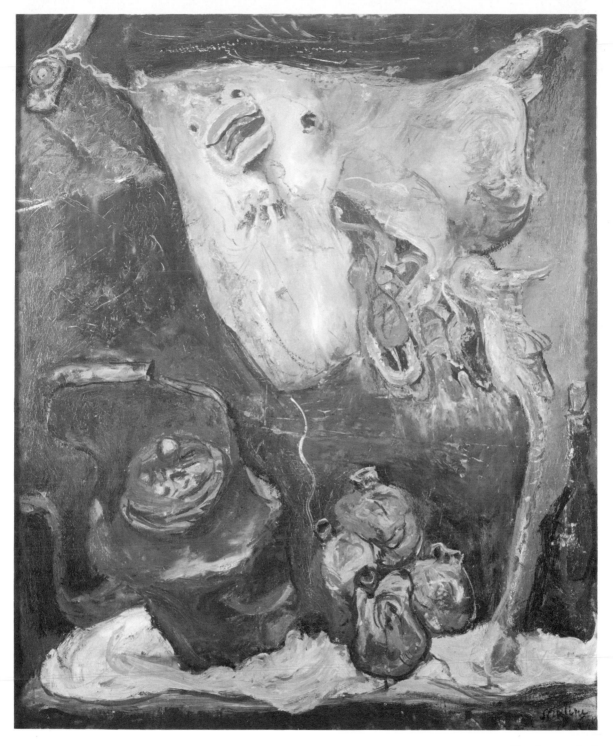

Caption overleaf

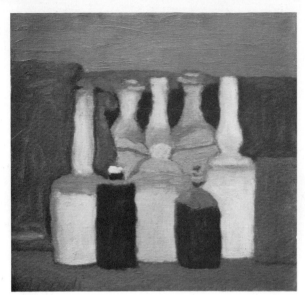

Giorgio Morandi (1890–1964)
Still Life with Bottles
Apart from a few metaphysical paintings done under the influence of his fellow countryman Georgio de Chirico around 1918–20, and a few early landscapes, Morandi devoted his entire painting years to still lifes of great simplicity and sensibility. He remained in Bologna, where he was born, all his life and lived untouched by the artistic experiments of this century. He produced many fine etchings based on similar groups of bottles, closely graded in tone and with a meticulous hatchwork of shading. They are strangely moving in their intense integrity.
Glasgow Museum of Art, Scotland

Caption to page 109
Chaim Soutine (1894–1943)
La Raie 81.3 cm × 65.1 cm
Soutine was born in Lithuania (now part of the USSR) the tenth of eleven children of a poor Jewish tailor. Many of his paintings seem to reflect the tragic and violent trappings of his own childhood, which were probably not dissimilar to those of Maxim Gorky. He emigrated to France at the age of seventeen where he met Modigliani, Picasso and Chagall, fellow exiles in that most cosmopolitan of cities. He painted many still lifes of turkeys and chickens, plucked or semi-plucked, tortuously hung against a background of dark red bricks, sides of beef reminiscent of Rembrandt, and a great series of Ray fish, or skate, painted with swirling brush strokes in impasto, using pinks and yellows and blue greens. He was a master in the use of white into which he introduced all the primary and secondary colours, so that every brush stroke seemed a different colour, yet the combined effect was of a dazzling whiteness. Many of his paintings of the skate were naturally based on the triangular shape of the fish itself—in this example he has tilted *The Ray* so that the design falls along both diagonals.
Hanna Fund (gift) Cleveland Museum of Art, Ohio

Postscript

I would like to learn. Could you tell me how to grow or is it unconveyed, like melody or witchcraft. Emily Dickinson (1830–1886) letter to Thomas Wentworth Higginson (April 26 1862)

There are unfortunately many great painters who have not been mentioned or reproduced in this book, and many recent painters who have not been represented. Since the advent of cubism and abstract expressionism in the early 1900s, still life painting has wandered from the strictly figurative approach with which this book is concerned, but that is not to say that the basic principles discussed here have been forgotten or neglected by those artists, nor by subsequent generations.

Impressionism was only one mode of expression in the late nineteenth century. Many artists at the same time were painting in their own way. So too today there are many painters following very different paths.

No artist knows what he will be painting in ten years time. Cezanne, Van Gogh, Picasso, all would have been as surprised as us if they had known, aged 25, what they would be painting a decade later. It is quite likely that in the time it has taken me to prepare this book some beautiful still lifes have been painted somewhere. I haven't yet seen them, I am sorry to say.

There have been of course inevitable limits set to a book of this size. Not only have there been the obvious restrictions laid down by the cost of materials but also the limitations imposed by the high fees demanded by some agents for the reproduction rights of artists, both dead and alive. Not withstanding this, I have been allowed a generous number of reproductions by my publisher, and we have received most courteous responses to requests both from private owners and National Galleries, to all of whom I am very grateful. I would have liked to have included examples of many more of the artists who worked in this genre and many more artists, again, who didn't, but whose work I love. The great English painters, Hogarth, Stubbs, Constable and Turner did not paint still life, nor did the great painters of the Renaissance. Alas, I could name many more!

Omissions have not been made with any prejudice on my part. I have tried to include all the different forms of this branch of painting in the hope that one of them at least will provide the initial spark that sets someone off. Wherever possible I have chosen works from public museums throughout the world so that my readers may in their travels and on their holidays see the original paintings. Reproductions give only a partial account of the real thing. The human eye can distinguish more than three times the number of gradations from black to white than can the camera. It is important to remember that in most colour reproductions only four colours are used, magenta, cyan (blue), yellow, and black. How unreliable these sometimes are can be seen by placing a reproduction alongside the original.

No form of reproduction has yet succeeded in conveying the sense of touch, the subtlety of the colour harmonies or the quality of paint of the great masters. Yet we must be grateful for the opportunity they give us to study at least the composition of the canvas and the general colour range, and to recall for us those

pictures that we have been fortunate to see.

Since the deaths this century of Picasso and Braque, Bonnard and Soutine, Morandi and Matisse, there have been few great names connected with still life painting. In a recently published history of modern painting, out of a total of nearly 500 illustrations, only twelve were devoted to still life, and of those only three were painted within the last fifty years.

It seems therefore that still life painting, so often the Cinderella of the arts, is back once again in the hands of the so-called primitives, the naives, the amateurs and of those solitary artists who paint on unaffected by fashion or by the demands of the dealers.

Let us go quietly on our way, working for ourselves. Vincent Van Gogh, Arles 1888

Glossary of terms

Alla prima The completion of a painting in one session, wet on wet.

Bloom The misty cloud on the surface of varnish due to damp.

Bodegon Spanish form of breakfast table paintings (lit. kitchen).

Body colour The use of white with water colours.

Broken colour The application of small strokes or dots of colour of differing strengths beside each other to give an overall effect of one tint at a distance.

Chassis French word for stretchers.

Chiaroscuro ie *clarus* and *obscurus,* brightness and shade. Usually refers to the use of strong lights and darks, giving a dramatic effect to the painting.

Collage Assembling heterogeneous materials, cloth, paper, balsa, wood, etc, stuck to a support, in a tactile manner.

Cracking This occurs when a quick drying colour is laid over a slower drying one, or one with more oil in it.

Cubism A post Cézanne movement instigated by Picasso and Braque *c* 1907 more concerned with the reality of an object than with its surface appearance.

Earth colours Clays stained with compounds of iron or manganese.

Fauve (wild beast) The name given to a group of artists using strong colours and flat patterns at the beginning of this century, including Matisse, Derain, Vlaminck and Roualt.

Fixative Liquid solution of gum and alcohol applied by spraying to drawings in charcoal, pencil or pastels to prevent smudging.

Fresco Painting executed in wet plaster.

Fugitive pigments Colours which fade or cause other colours to fade when mixed with them.

Genre Paintings of everyday home life, from peasants to more prosperous surroundings, of which still life painting is a branch.

Gesso A mixture of whiting and glue size used for priming the support for tempera and some oil paintings.

Glazing The laying on of a transparent wash over an already dried paint surface so that the colour is altered and darkened.

Gouache Opaque water colour.

Grisaille Monochrome painting in greys or neutral colours. Can also be the first stage in building up an oil painting.

Ground The surface, upon which the picture is painted, which has received a preliminary preparation, often a tonal gradation of grey or sienna. A primer is frequently referred to as a ground.

Handling The application of paint to canvas.

Hard edge A style of abstract painting using clear cut edges.

Impasto Thick paint.

Impressionism A method of expressing a general effect without elaborate detail but with the emphasis on exact tone and colour achieved by studying the light on the surface of things.

Imprimatura Undercoat of colour on the ground.

Keys Wooden wedges, used two in each corner to spread the stretchers and tighten the canvas.

Local colour The real colour of an object uninfluenced by light or dark or by juxtaposition with another colour.

Mahl stick A cane (padded at one end to prevent harm to the canvas) upon which an artist rest his wrist and steadies his hand when painting fine detail.

Medium Liquid added to pigments to make them workable.

Monochrome Painting in various gradations of one colour.

Op art A twentieth century term for a form of abstract art using optical effect to give an illusion of movement.

Opaque Non transparent.

Optical mixture Unmixed dots or lines of colour laid side by side so that the effect when seen from a distance is similar to that of the colours having been mixed on the palette.

Palette Flat object, of various substances, upon which the artists colours are laid out. The word also applies to the choice of colours used by the individual artist.

Peinture Claire Alla prima painting, working from light to dark.

Pointillusion See *Optical mixture.*

Primary colours Red, yellow, blue.

Primitives Untrained—formerly applied to painters working before the fourteenth century but now used to describe the genuinely self-taught.

Priming The first coat of surface covering, usually size and lead white for oil paintings.

Quality The fine degree with which the paint is handled.

Scumbling Dry paint stippled over a dry under layer, only partially hiding that layer, and lightening the effect.

Secondary colours Mixing two primaries to obtain green, orange, or violet.

Stretcher The wooden frame upon which the canvas is stretched.

Support The canvas, wood, paper, wall, etc, upon which the priming and ground is to be placed to take the painting.

Surrealism Irrational vision. In a surrealist painting 'any conscious mental control of reason, taste or will, is out of place.' (Max Ernst 1891–1976)

Tactile values The rendering of substances by the quality of the paint.

Tempera Powder colour mixed with egg, which dries almost immediately when used on a gesso ground.

Tertiary colours There are obtained by mixing the three primaries in varying proportions.

Textures The surface appearances of different objects, materials and minerals etc.

Tint A colour weakened by another, usually white.

Tonking A method of removing some surplus paint from the canvas yet leaving some trace of colour behind. So called after Professor Tonks (1862–1937) of the Slade School of Art, London.

Trompe l'oeil (lit. deceive the eye) An exact imitation giving the illusion of being real.

Values Different degrees of intensity of brightness and dullness.

Vanitas Object painting that reminds one of the transience of life.

Vehicle Another word for the medium or fluid used in working the pigment.

Wash A transparent layer of thin paint.

Bibliography

General

Artists on Art, compiled and edited by Robert Goldwater and Marco Treves, Pantheon Books, New York

Illusion in Art-Trompe L'oeil, M. L. d'Otrange Mastai, Secker and Warburg, London

Dutch Still Life Painting in the Seventeenth Century, Ingvar Bergstrom, Faber, London

The Journal of Eugène Delacroix, Phaidon Press, London

Camille Pissarro, Letters to his Son Lucien, edited by John Rewald, Kegan Paul, Trench, Trubner, London

Letters of Van Gogh, edited by W. H. Auden, Thames and Hudson, London

Larousse, Encyclopedia of Renaissance and Baroque Art, Hamlyn, London

Larousse, Encyclopedia of Modern Art, Hamlyn, London

The Flowering of American Folk Art, Jean Lipman and Alice Winchester, Viking Press, New York

Know the Gallery, W. R. Dalzell, The National Gallery, London

André L'Hote, Treatise on Landscape Painting, Zwemmer, London

The Cubist Epoch, Douglas Cooper, Phaidon Press, London

A Dictionary of Art and Artists, Peter and Linda Murray, Penguin Books, London

The Oxford Companion of Art, Oxford University Press

History of American Painting, Mathew Baigell, Thames & Hudson

Still Life Painting, Charles Sterling, Edition Pierre Tigne, Paris

Practical and Technical

A Guide to Traditional and Modern Painting Methods, F. Taubes, Thames and Hudson, London

Introducing Oil Painting, Michael Pope, Batsford, London

Introducing Water-colour Painting, Michael Pope, Batsford, London

Colour Matching and Mixing, Alfred Hickethier, Batsford, London

Methods and Materials of Painting of the Great Schools and Masters, Sir Charles Lock Eastlake PRA, Dover Publications, New York

Notes on Colour Mixing, Hesketh Hubbard, Winsor and Newton, Middlesex

The Practice and History of Painting, John Mills, Arnold, London

Notes on the Technique of Painting, Hilaire Hiler, Faber, London

The Artist's Handbook of Materials and Techniques, Ralph Mayer, Faber, London

Painting Sharp Focus Still Lives, Ken Davis and Ellye Bloom, Watson-Guptill, New York

The Painters Pocket Book of Methods and Materials, Hilaire Hiler

The Technique of Oil Painting, Colin Hayes, Batsford, London

The Technique of Water Colour Painting, Colin Hayes, Batsford, London

Figure Painting, Hans Schwarz, Studio Vista, London

Suppliers

Great Britain

L Cornelissen and Son
22 Great Queen Street
London WC2

Crafts Unlimited
178 Kensington High St
London W8

11 Precinct Centre
Oxford Road
Manchester 13

202 Bath Street
Glasgow C2

88 Bellgrove Road
Welling, Kent

Reeves and Sons Ltd
Lincoln Road
Enfield, Middlesex

Robersons and Co Ltd
71 Parkway
London NW1

George Rowney and Co Ltd
10 Percy Street
London W1

Winsor and Newton Ltd
51 Rathbone Place
London W1

Stretchers
Bird and Davis Ltd
52 Rochester Place
London NW1

Paper specialists
Falkiner Fine Papers Ltd
4 Mart Street, off Floral Street
Covent Garden, London WC2E 8DE

USA

Arthur Brown and Bro Inc
2 West 46 Street
New York

The Morilla Company Inc
43 21st Street
Long Island City, New York
and 2866 West 7 Street
Los Angeles
California

Stafford-Reeves Inc
626 Greenwich Street
New York, NY 08701

Winsor and Newton Inc
555 Winsor Drive,
Secaucus
New Jersey 07094

Paper specialists

Hobart Paper Co
11 West Washington Street
Chicago, Illinois 60600

Wellman Paper Co
308 West Broadway
New York, NY 10012

Index

Numerals in *italics* refer to pages on which illustrations appear